HOW TO DRAW

People

A STEP-BY-STEP GUIDE FOR BEGINNERS WITH 10 PROJECTS

SUSIE HODGE

NEW
HOLLAND

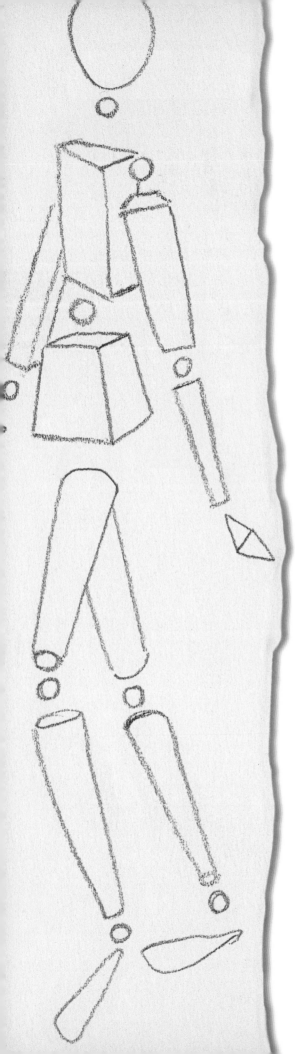

DEDICATION
To my parents, Jean and Stan

Reprinted in 2009
NEW HOLLAND PUBLISHERS (UK) LTD
London • Cape Town • Sydney • Auckland

Garfield House
86–88 Edgware Road
London W2 2EA
www.newhollandpublishers.com

80 McKenzie Street
Cape Town 8001
South Africa

Unit 1, 66 Gibbes Street
Chatswood
NSW 2067
Australia

218 Lake Road
Northcote
Auckland
New Zealand

10 9 8 7 6 5

ISBN 978 1 84537 050 3

Senior Editor: CORINNE MASCIOCCHI
Design: BRIDGEWATER BOOK COMPANY
Photography: SHONA WOOD
Editorial Direction: ROSEMARY WILKINSON
Production: HAZEL KIRKMAN

Reproduction by Pica Digital PTE Ltd, Singapore
Printed and bound by Times Offset (M) Sdn. Bhd., Malaysia

NOTE
Every effort has been made to present clear and accurate instructions.
Therefore, the author and publishers can offer no guarantee or accept
any liability for any injury, illness or damage which may inadvertently
be caused to the user while following these instructions.

ACKNOWLEDGEMENTS
Thank you to Corinne, Clare, Rosemary, Shona and Hazel for
all their hard work and to everyone who appears in this book.

Contents

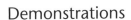

Introduction

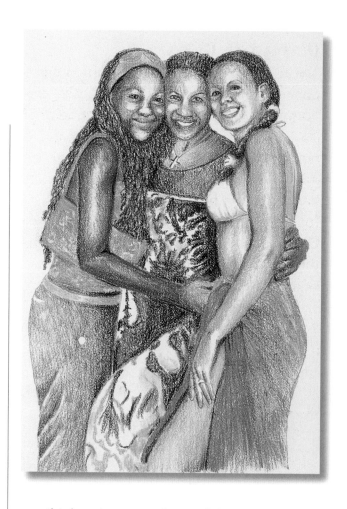

Some of the most outstanding works of art have developed through a fascination for the human form. Yet the portrayal of the human image has always reflected the cultural and religious attitudes of the time and place it was made. The Ancient Egyptians followed meticulous guidelines for their art; the Greeks were concerned with ideal beauty and Renaissance artists developed an interest in anatomy. In the 19th century, photography changed everything. Artists became familiar with natural poses and movements of people at their daily tasks, and 20th-century artists pushed creativity further than ever, with distortions depicting more than just a photographic image.

For centuries, life drawing has been an integral part of Western artists' training. Yet, like portraits, drawing people is often considered to be more challenging than most subjects. But, as with most things, it's about looking analytically and drawing the shapes you see.

Everyone can learn to draw well – a drawing is only a series of marks; so don't let it get the better of you!

There are two points to remember before you begin to draw. First, become accustomed to looking objectively. Whatever you are drawing, see it as an arrangement of shapes, proportions, angles, tones, colours and textures. Most of us draw what we remember, not what we actually see. Even if we think we've looked carefully, there is a gap between looking and drawing where our subconscious takes over and we draw what

we *think* we've seen. Second, become familiar with your materials' capabilities. With a little patience and a lot of practice, your drawing technique will improve considerably.

Drawing people is one of the most exciting and rewarding subjects. This book shows you all you need to know and you will be amazed at what you can achieve. The instructions and advice will help you to become aware of how to look analytically and how to use different materials. There is information about proportion, posture and balance, how to create the illusion of solidity and movement, how to make clothes look convincing and how to capture other elusive qualities that give figure drawings life and likeness.

Using the Book

The 10 step-by-step demonstrations in this book show a variety of people and poses drawn with a range of materials. The steps illustrate different stages in each drawing's progress, with details about handling materials, subjects and situations. You may find it easier to begin with Demonstration 1 (pages 18–23) as this is the simplest project. Or you might prefer to dip in and out of the book, as all the demonstrations have valuable hints, tips and information for various ways of drawing figures. As well as the main drawing, each demonstration includes an alternative drawing of the same subject in a different material showing further possibilities along with a photograph of another pose for you to try out with your chosen treatment.

Remember that there is no one way to draw. All artists have their own way of responding to a subject and the beauty of art is that very thing – whatever you do is right for you. Don't be intimidated by the finish of any of the drawings here, nor be disheartened if you make some mistakes along the way. You can always stop drawing at any point, leaving your picture lighter and sketchier. But most important of all, relax; enjoy your drawing and the results will follow!

FINAL DRAWING

STEP-BY-STEPS

TRY A DIFFERENT ...

SUBJECT

ALTERNATIVE DRAWING IN A DIFFERENT MEDIUM

ALTERNATIVE SUBJECT POSE

Tools and Materials

Despite many technological advances, artists' materials have changed little over the centuries. Nowadays, most materials are easier to use and there is a wider range of pigments available, but essentially, the way we use them remains virtually unchanged. The materials described here are used in the demonstrations and are fairly inexpensive, but only buy what you need to begin with. It doesn't take long to become familiar with the materials and you'll soon find that you're using them quite unselfconsciously.

PENCILS are made from graphite and clay, encased in wood to protect them and make them easier to hold. They are graded from hard (H) to soft (B). 9H is the hardest whereas 9B is the softest, with F for fine and HB in the middle range. H pencils are good for clear-cut, light lines, while B pencils are better for softer, tonal work. Mechanical or propelling pencils are good for precision drawing but the softest grades are hard to find.

GRAPHITE STICKS are solid graphite sticks without a casing, so both the sides and tips can be used. Like pencils, they are graded in hardness and are good for sketching and blending. Thin graphite sticks often have a lacquer coating and water-soluble graphite pencils can be blended with water on paper.

WHITE CHALK comes in hard sticks, which can add effective details or soft pastels, which are easier for blending.

CHARCOAL AND CHARCOAL PENCILS are essentially charred wood – usually willow. Charcoal comes in various degrees of thickness and softness. It can be used to produce delicate lines or dense tones and can be smudged and blended easily. Compressed charcoal is also available, which

PENCILS

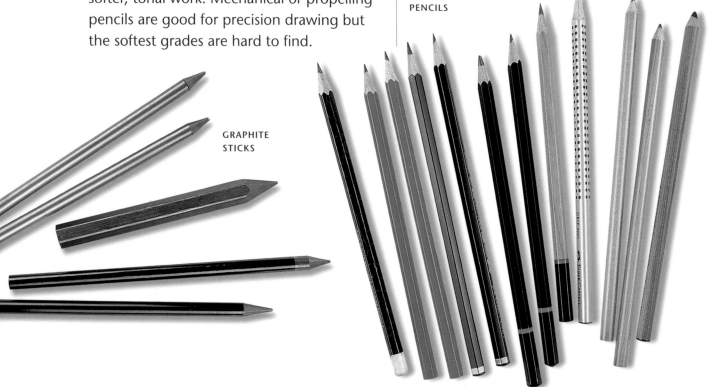

GRAPHITE STICKS

produces strong marks that are not easy to erase. Charcoal pencils come in a wooden casing and are less messy than other types of charcoal but these are less easy to blend and erase. Charcoal drawings need to be sprayed with fixative to preserve them.

CONTÉ CRAYONS, STICKS AND PENCILS are made of natural pigments bound with gum Arabic. The most popular – and traditional – colours are black, white, sepia, sanguine and bistre. These last three are reddish browns. Conté crayons, sticks and pencils are also available in a wide range of other colours. They are effective for crisp, decisive lines and for solid areas of tone. They can be smudged and blended but are not easily erased.

COLOURED PENCILS come in a variety of qualities and softnesses and in many different forms: standard, water-soluble and thick- and thin-leaded. The pigments are mixed with clay, a binder and wax to help the pencils glide smoothly over the paper and the colour to adhere. Some coloured pencils make sharp, definite lines, while others are softer and can be blended more easily. Layering colours will produce different shades and unexpected results can be achieved by using the same group of colours in different sequences, so it's worth experimenting.

PASTEL PENCILS are thin sticks of hard pastel inside wooden casings. They are easy to work with – similar to Conté and charcoal – and they come in a huge range of colours. They are particularly effective when used on coloured paper. Like charcoal, pastel drawings need to be sprayed with fixative to preserve them.

COLOURED AND PASTEL PENCILS

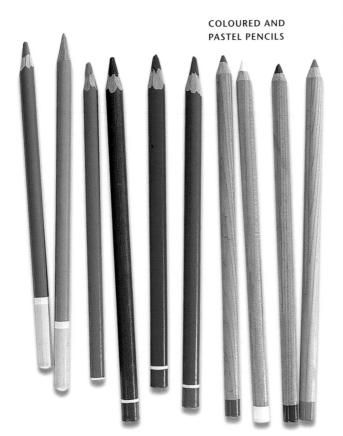

CHARCOAL, ARTIST'S PENCILS AND CARRÉ STICKS

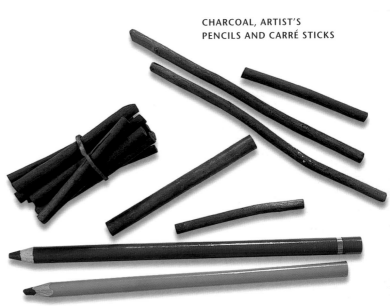

PENS are available in many different varieties. Dip pens have interchangeable steel nibs. Pointed nibs are good for drawing the figure, although square, chiselled and rounded nibs can all produce interesting results. Reed and bamboo pens are also effective – reed pens make fine lines, while bamboo pens produce coarser lines. Fountain or cartridge pens, fine liners, specialist art pens, technical pens, fibre tips and ballpoint pens are all convenient and can create flowing lines. The main drawback with these pens is the lack of variation you can achieve with the line, although they are excellent for producing hatched, stippled and cross-hatched drawings. You can also vary the tone with some pens by blending with a brush and water.

INKS are either water-soluble or waterproof. Both can be blended with water to create tones, but whereas waterproof ink will dry 'fixed', water-soluble ink can be re-wet and re-worked. There are various rich colours available in both waterproof and water-soluble varieties, but the most popular for drawing the figure is black Indian ink, which when diluted, becomes an intense sepia colour.

SHARPENERS come in many different forms. A craft knife is best for sharpening pastel pencils, coloured pencils and pencils, as well as trimming dirty edges from erasers. Knives allow you to sharpen the point of your medium to suit the type of work you are doing – such as long, short or angled. Pencil sharpeners make a neat point and are best for graphite sticks.

ERASERS AND STUMPS Kneaded erasers or putty rubbers can be squashed or pulled into small shapes and angles to erase mistakes or to 'lift out' highlights. Firmer erasers can be used to clean grubby areas and to adjust small errors. For blending charcoal, Conté or pastel pencils, a useful little tool is the torchon or tortillon – a pencil-like rigid tube of rolled paper with pointed tips. This can be used to move or press pigment into the paper, creating a range of tones.

FIXATIVE prevents drawings made with pencil, charcoal or other soft pigment from smudging. It is made by dissolving a resin in a colourless spirit solvent. When you spray it on to a drawing, the spirit solvent evaporates and a thin coating of resin is left behind to bind the pigment dust to the support. Once fixed however, the drawing cannot be altered, although you can draw on top of fixed drawings. It is common practice to fix a drawing periodically whilst working on it.

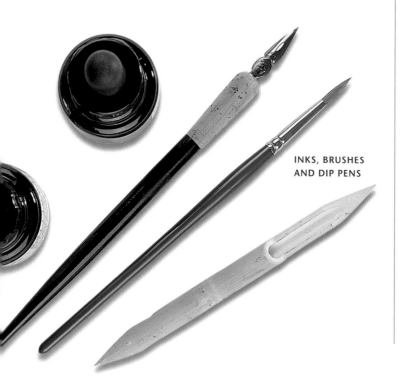

INKS, BRUSHES
AND DIP PENS

PAPER AND SUPPORTS The media you use will be affected by the surface of your paper or support, so it is wise to match the support to the material. There are three main paper surfaces. Rough has a textured surface and is best suited to charcoal, chalk, pastel pencils, soft graphite sticks or pencils. Smooth-surfaced papers are known as 'hot pressed'. They are ideal for pen and ink, line and wash, and some pencil and coloured pencil drawings. Papers with a medium surface are called 'cold pressed' or 'NOT', because they are not hot pressed. These papers have a slight 'tooth' and work well with most materials. Most papers are white or cream but coloured papers are ideal for pastel, charcoal and chalks. Unless stated otherwise, most of the drawings in this book have been drawn on standard cartridge paper, the most versatile paper for most types of drawing and readily available in a variety of weights and colours. Sketchbooks, available in many different sizes and formats, contain various types of papers. There are no rules about what type of sketchbook you should use, just use it often!

DRAWING BOARDS AND EASELS It is easier to work with your paper or support secured to a drawing board and you can prop this board on a few books or you may prefer an easel. A good choice is an adjustable table easel, which you would use only when you are drawing sitting down. For drawing outside or standing, a sketching easel is useful but not essential.

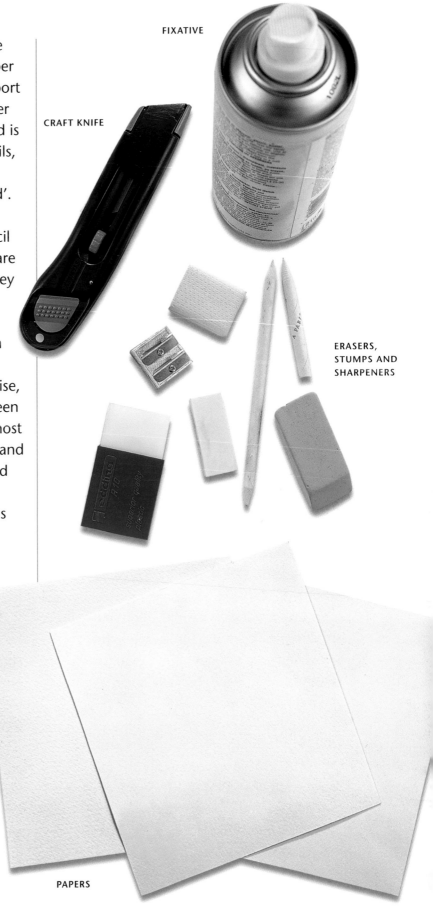

FIXATIVE

CRAFT KNIFE

ERASERS, STUMPS AND SHARPENERS

PAPERS

Basic Techniques

There is no right or wrong way to draw people. After assimilating all you've learned, your brain, unknown to you, puts everything together in the style that suits you best. This is a unique combination of your own aesthetics, education and experience. These pages will guide you through some of the techniques you'll need.

Before you begin, a word of advice about the *way* you draw. The greater the ease with which you can move your arm, wrist and hand, the less limited you will be in your drawing movements and in your ability to express yourself. Flexibility of your hand, wrist and arm enables you to place line or tone in any direction. Next, hold your drawing medium further back than you would hold a writing implement. This will increase your range of motion and the variety of strokes you are able to make and so boost your expressive abilities.

The techniques shown here should be practised often, like a pianist practises scales. In this way, drawing people, analyzing structure, establishing tones, assessing people as simple shapes and drawing foreshortened features will all become second nature.

LINE
Our eyes don't draw round an object and make a line that joins up. This idea of drawing an outline is a symbol that we have learned from childhood, yet line is traditionally used to show shapes of everything we draw. By varying lines we

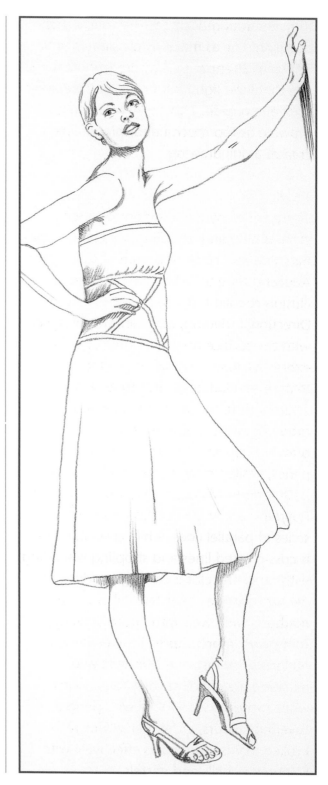

LINE

can show a lot more than simply the outer rim of a person. Concise lines for instance, give a sharp silhouette, separate from the world, while short, broken lines can give the impression of movement. Try to vary the quality of line as much as possible in your drawing. Strengthen it where you want the eye to follow, lighten it where you want the image to recede. This can give life to a drawing as too much uniformity of line creates a dull drawing.

TONE

There are many ways of depicting tone, such as blending, stippling, hatching, cross-hatching and contour or directional shading. Applying tone to a drawing provides an illusion of solid form and gives it weight. Directional shading, for example, interacts with the surface texture of the paper in an expressive way and can be used to depict textures of clothes or hair, for instance.

Smooth tones should be blended gradually, with careful pressure on your drawing implement, such as graphite or pencil, while Conté, pastel or charcoal can be smudged with your finger or a torchon. Hatching is a way of adding tones using a series of parallel lines, while cross-hatching is criss-crossed lines and stippling is shading with dots. The closer the lines or dots, the denser the tones depicted. All of these methods work well with figure drawing, but some work more impressively with certain materials, for instance, stippling and hatching are effective with pen and ink, while blending works well with pencil. Layering colours, either densely or with broken marks, also works effectively with coloured pencils and pastels.

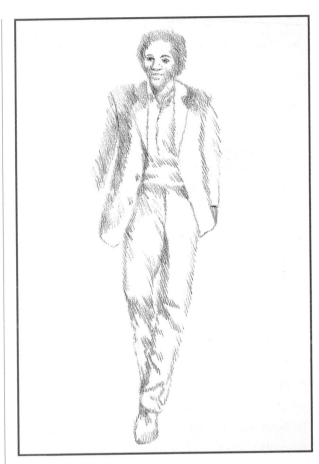

HATCHED TONE

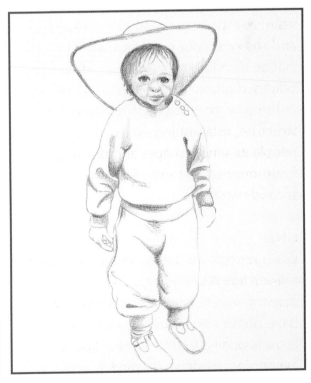

LINE AND TONE

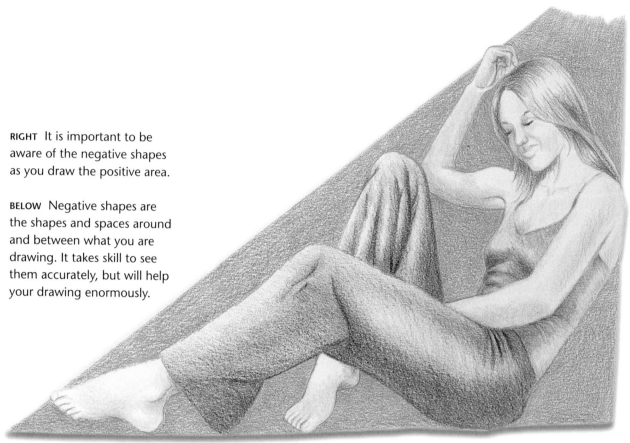

RIGHT It is important to be aware of the negative shapes as you draw the positive area.

BELOW Negative shapes are the shapes and spaces around and between what you are drawing. It takes skill to see them accurately, but will help your drawing enormously.

POSITIVE SHAPES

STRUCTURE

Observe and draw negative spaces around figures as carefully as you draw the positive shapes. Drawing these abstract shapes are much easier than determining the angles of the body as they stop your subconscious taking over, telling you what you think the figure looks like.

Another way to help yourself when observing the structure of your subject is to see the simple shapes that make up the human figure. Everything is made up of basic geometric shapes and these can make sense of a seemingly complex drawing. If you simplify what you are looking at into circles, cones, cylinders, boxes or other basic shapes, you will once more be training your eye to view your subject objectively.

NEGATIVE SPACE

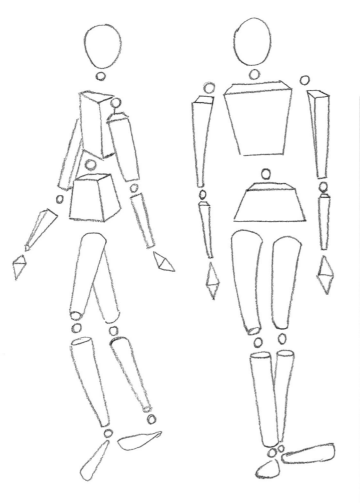

THE BODY AS SIMPLE GEOMETRIC SHAPES

ANATOMY

It is useful to know some of the underlying anatomy of figures before drawing them. You don't have to know all the bones, but a general understanding of the bone structure beneath the flesh will help to make your drawings convincing. Remember too that the joints are the springs, which articulate movement. The shoulder blades form two triangles with sockets for the arms and the key to any pose is the position of the backbone. At the top of this are the shoulders from which hang the arms and at the bottom, the pelvic girdle or hips allows movement of the legs. The backbone bends and curves to support the tilts of the shoulders and hips. Where the bones bend, the covering clothes are pulled, so it's important to know where these bends occur.

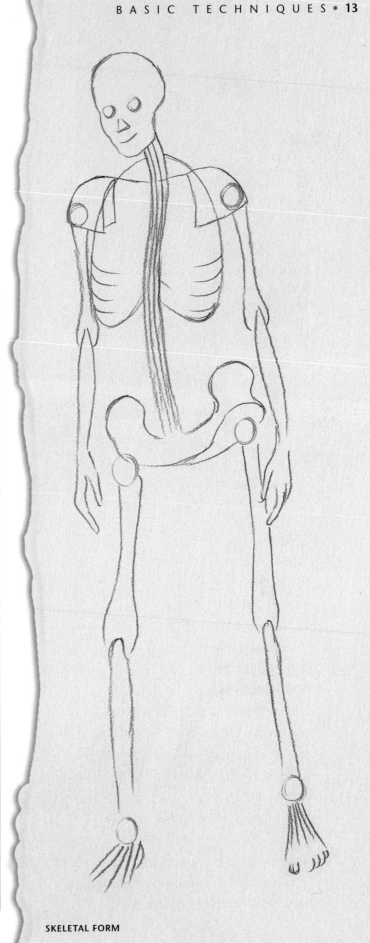

SKELETAL FORM

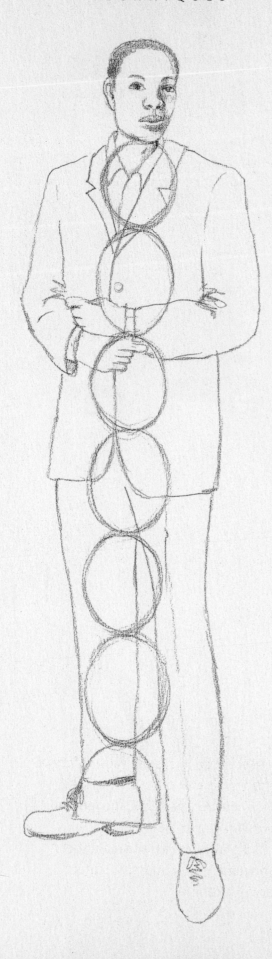

PROPORTION

The usual method of ensuring that the relative sizes of various parts of the body are in proportion is to use the length of the head as a measurement. An average adult figure is about seven and a half heads high. Fashion illustrations exaggerate leg lengths which means a figure can be up to ten heads high! Babies are made up of about three head lengths, with about six for an older child.

In childhood, male and female body shapes are similar, but in adults, fat is distributed differently. Women have thighs, breasts and rounded hips, while men have broader shoulders and thicker necks. Overweight men usually have larger waists than hips, whereas overweight women are usually bigger at the hips than the waist, the main sites of fat storage being the thighs, breasts, buttocks and lower abdomen. Both men and women store fat on the upper arms and between and above the shoulder blades.

FORESHORTENING

The body, like any other object, appears larger when close to the viewer and smaller as it recedes into the distance, and its proportions appear to alter. This is called foreshortening. The body can assume odd shapes when it appears foreshortened so don't mistrust your eyes however unlikely an angle or shape you might see. Any part of the body that is projected towards you will appear foreshortened and the proportions will vary depending on your viewpoint. For example, a hand held out in front of the face will appear much larger in relation to the head when seen from close up, but will reduce in size as you move away.

PROPORTION

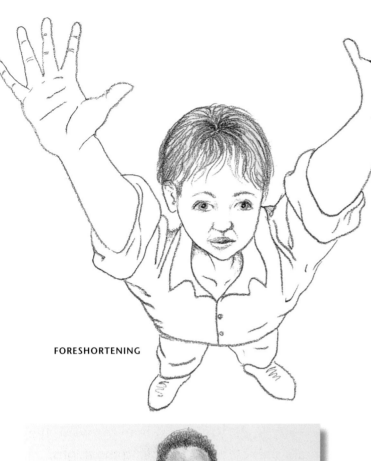

LEFT Foreshortening occurs in almost everything you draw. Be aware of the distortions and include them for accuracy.

BELOW Look for rhythm and continuity in folds of fabric on the body. As you draw folds, look out for curves to indicate the body beneath.

FORESHORTENING

CLOTHES

CLOTHES

It is a useful exercise to sketch folds in fabrics and their movement as they hang on the body. Study textures, patterns, movement and draped fabrics and see how clothes crease and fold around joints. Remember that the movement of a figure will affect the drapery of clothing.

CLOTHES

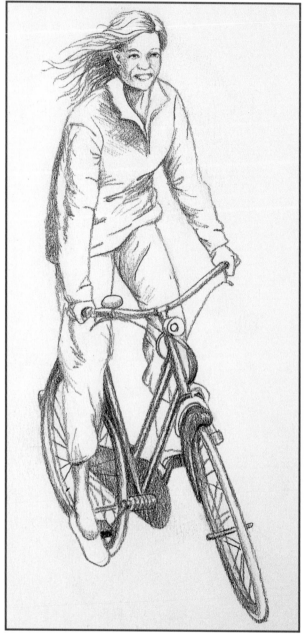

MOVEMENT

QUICK SKETCH

ABOVE To give the impression of movement, draw rhythmical folds in the clothes and flowing hair.

BELOW When the body twists, clothes create spiral folds. The folds and creases describe gestures and movements of the body beneath.

MOVEMENT

To create the illusion of movement, you have to develop what you know of basic anatomy and also draw from observation. The distribution of weight and the point of balance vary as the figure moves, so it's hard to draw a moving figure from a stationary pose.

SKETCHBOOKS

It's a good idea to keep a sketchbook. Don't feel self-conscious – take a sketchbook wherever you can and use it to make quick scribbles or to work out compositions. Forget about details and draw abbreviated sketches, experimenting with thumbnail ideas and groups of figures. If they work in rough, they'll work when you draw them more precisely later.

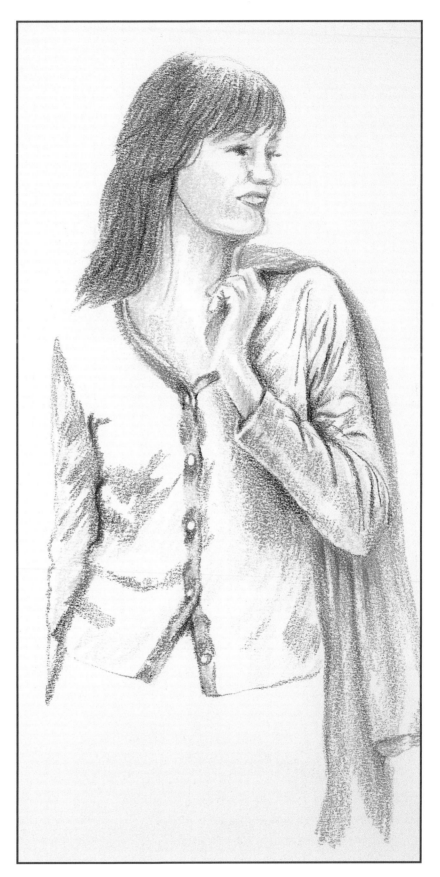

MOVEMENT 3

Demonstration 1

Young woman standing
Charcoal

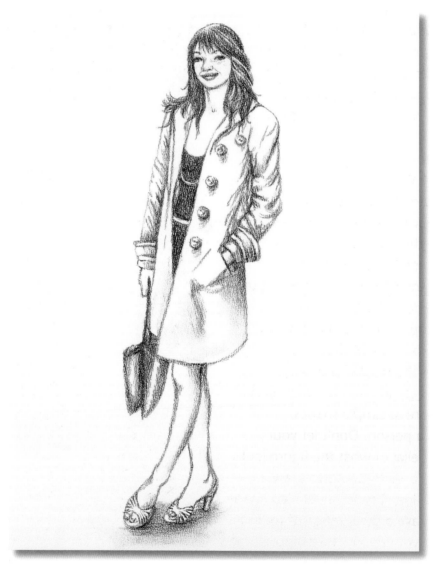

Charcoal is the traditional material that artists use when learning to draw figures and the chosen material of many artists when planning more detailed drawings and paintings. For this reason, it's an ideal medium for the first drawing of a simple, standing figure. You can't become over-involved with details, as the charcoal won't

let you! Charcoal works well on most paper, whether textured or smooth, but it needs to be applied lightly. If you rub it with an ordinary eraser, it will smudge into the paper, making a dark smear. Instead, if you need to erase it, press and lift with an eraser or lightly blend away mistakes with some kitchen towel or a piece of rag, then make corrections over the top. You will find that as soon as you touch the paper with the charcoal it will make a mark, which can be blurred or blended with your finger or a torchon to model different tones. Aim to make these tones as varied as you can, emphasizing contrasts. For a first figure drawing, concentrate primarily on getting the shapes and proportions right, then look at ways to 'shape' the image, such as drawing light fold or crease lines in the clothes and adding the lightest of tonal marks, but nothing heavy or too meticulous.

Subject

Drawing is more about attitude than talent – the greater your application and the more risks you take, the greater the rewards will be. So be determined to get the shapes right, look for the angles and spaces around the figure and don't be disheartened if your first attempts don't turn out as you wanted them to – you will learn as you draw whatever the results, which is an achievement in itself. For this first project, look at the figure as simple shapes, rather than as a person. Don't let your subconscious belief of what the figure looks like take over. You are aiming to draw a convincing outline; it is not a detailed image and does not have a great range of tones in it. Because the young lady is wearing a coat, you won't have to worry too much about specific shapes of the body, but you will have to get the proportions right.

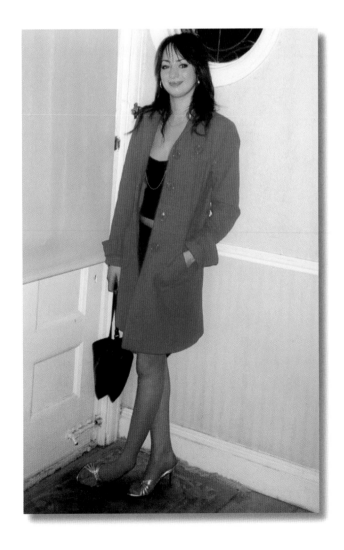

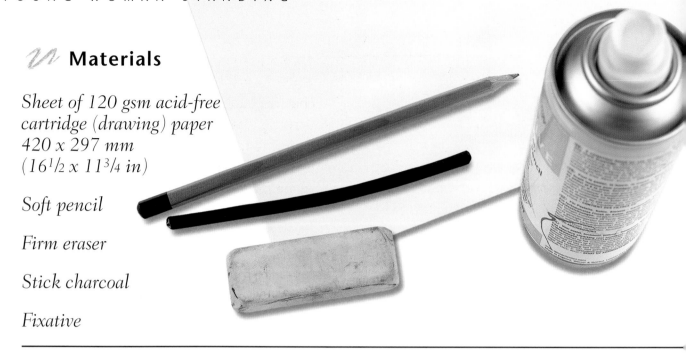

𝓂 Materials

*Sheet of 120 gsm acid-free
cartridge (drawing) paper
420 x 297 mm
(16¹/₂ x 11³/₄ in)*

Soft pencil

Firm eraser

Stick charcoal

Fixative

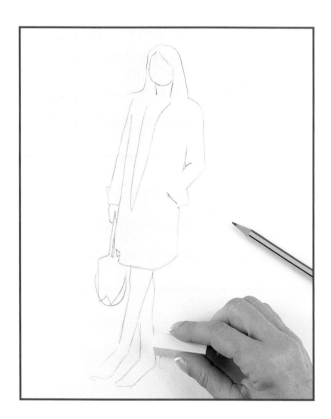

1 Start by looking at the figure, and
 making rough marks using the soft pencil
on your paper. You are simply looking for
shapes, positions and angles. Note the
negative shapes around the girl, such as

between the head and shoulders, between
the ankles and around the elbow. This will
help you to mark on the correct proportions.
Some common beginners' mistakes include
drawing arms too short, hands and feet
too small and the shoulders and neck too
narrow. Often, the angle at which you see
your subject obscures these lengths and
widths through foreshortening, which is
why drawing the negative shapes will help.

Figure drawings often go wrong because
the proportions are not properly understood,
and although human figures vary greatly, it
is helpful to bear in mind some basic rules.
As well as the measurements shown in *Basic
Techniques* (see page 13), there are about
four head lengths in the legs and three head
lengths in the torso in an adult figure. Bear
this in mind as you go over your initial pencil
lines, shaping them just a little more and
erasing the earlier, angled lines. Begin to
shape the face and hair, mark on the length
of the coat opening and draw in the outline
of the handbag.

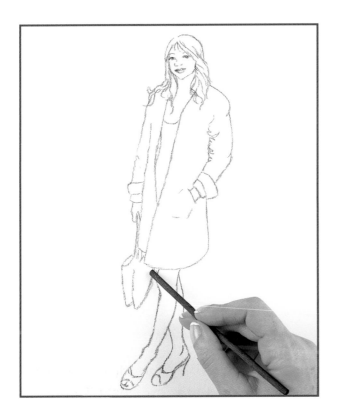

2 Begin to use the charcoal. Normally, you would start a charcoal drawing with charcoal, but because this is a first figure drawing, the pencil will give you confidence. Lightly touch the paper with the charcoal, as pressing will break the stick. Begin to shape the legs and bag, with a light, broken outline. Draw in some hair to establish where it will be and a line for the neckline under the coat.

Draw over your pencil lines. Keep a firm grip on the charcoal, holding it fairly far back and touching the paper lightly in short bursts. Lightly draw in the facial features, the shape of the bag and the cuffs. You are still only drawing outlines, except in the hair where you should draw lines where the hair is darkest. Mark on some of the straps of the shoes – again, only where they are darkest. Look at the shape of the feet and the angle of the shoe heel and how it supports the leg.

Artist's tip
You may find that charcoal smudges under your working hand. If this happens, try resting your drawing hand on a sheet of paper or kitchen towel, or smudge the charcoal as you work to soften the image, then draw with sharper lines at the end.

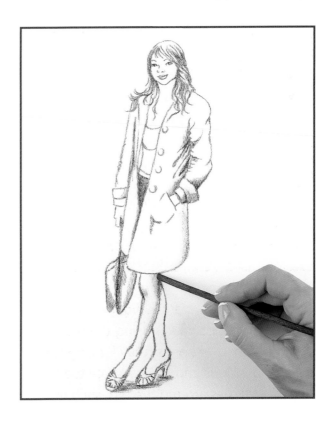

3 Add some tones to the right arm, the part of the coat where the model has her hand in her pocket and on the bag. Add some tone under the chin, on the legs and draw in the shape of the four buttons on the coat. Where the coat is open, begin to draw in the chain necklace and the top and skirt. Add a little sketchy tone where the coat folds and creases and shape the shoes in a little more detail. Put a little shadow under the front foot.

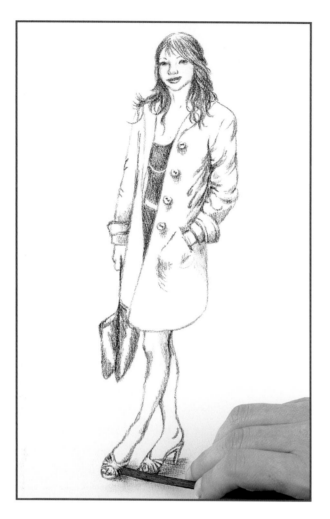

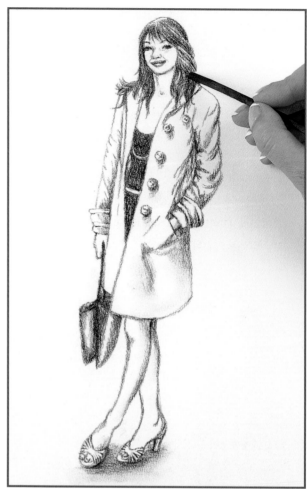

4 Shade the clothes beneath the coat, the bag and the edges of the legs and go over the creases and folds of the coat with some light, hatched strokes. Make the lines darker in areas of shadow. Pick out some details on the buttons and half close your eyes to see if the tones are balanced. If they are not, adjust them using either a torchon, a kneadable eraser or your finger to lighten some and layer more charcoal over areas that need darkening.

5 Use diagonal hatching lines or scribbles to build up tones, blending and spreading them where necessary. Work on the facial features carefully – the eyes are half way down the head, with an eye's distance between them. Hair should be drawn in lines in the direction that it grows or is styled. Build up the tones on the coat, legs and face lightly, and shape the buttons and bag with stronger marks where they appear darkest. Draw in the necklace with a light line around the neck.

TRY A DIFFERENT ...

... MEDIUM

Draw this same picture in pencil, using a medium soft pencil, such as a 2B or 3B. Although pencil is not as dramatic as charcoal, it can achieve a wider range of tones and far more details, giving the same picture a different personality.

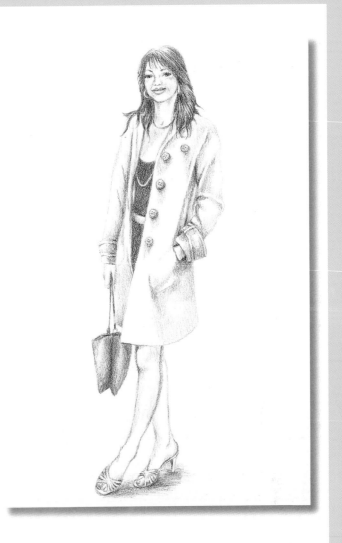

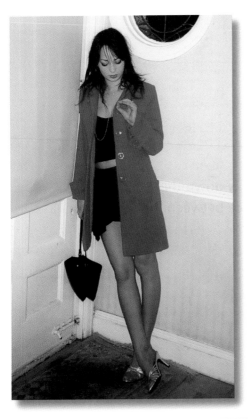

... POSE

As in a life drawing class, several variations of the image are possible by simply moving the model around or making her look in a different direction. This has the same lighting, but the way that the young lady is standing and looking makes it entirely different to the other pose.

Demonstration 2

Young man standing
Soft pencils

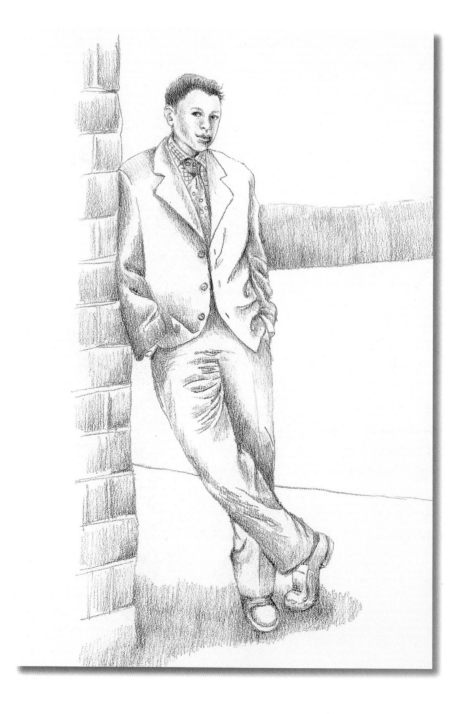

Soft pencils can produce a range of versatile marks and can create a variety of tones and textures. They are comfortable to work with and are what most people are accustomed to drawing with. They are also easily erased, so you can use an eraser for removing errors and to 'lift out' highlights. Soft pencils work well for tonal drawings while harder pencils can be used for more linear drawings. Consider what support you will work on – a textured surface will supplement textural marks, while smooth paper will give a smoother finish. It is worth trying out both to see what you prefer.

Subject

Experiment before you settle on a pose to ensure that it will work well on paper. Remember that some foreshortening can give an odd look, so try to imagine the person as a drawing on paper. When you have decided on the pose, look for negative spaces – the shapes around the person – and, as you work, continue viewing the subject as a series of shapes and angles in order to draw the correct proportions. This pose is upright, but relaxed; there are no limbs in awkward positions and no difficult angles, so quite a straightforward subject to draw.

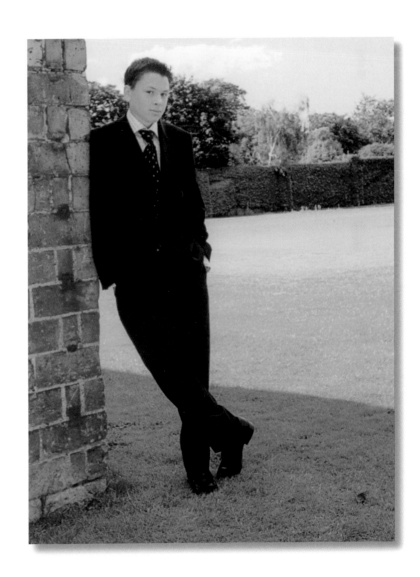

Materials

Sheet of 120 gsm acid-free smooth cartridge (drawing) paper 420 x 297 mm (16¹/₂ x 11³/₄ in)

2B and 4B pencils

Firm eraser

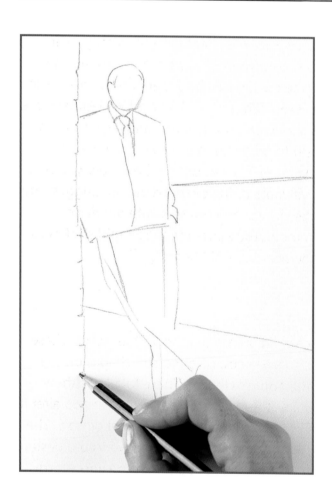

1 Study the photo and note the angles of the shoulders, hips, legs and head. With the 2B pencil, draw a vertical line to indicate the wall that the young man is leaning against, and draw the diagonal lines of shadow and bush – nothing detailed at this early stage, just an indication to hold the subject together and to draw the viewer's eyes into the picture. Bear in mind the proportions of the adult human body and be careful to make the body about seven and a half heads high. Mark this on in lines and also mark on the angle of the shoulders and hips. The shoulders appear wider than usual because of the bulkiness of the jacket.

Now start shaping the subject by marking in the collar and tie and 'filling out' the legs. Don't worry about pencil smudges on your paper. Developing flexibility as you draw is more important than creating an immaculate drawing and you can always erase any dirty marks at the end. Start to hint at the bricks in the wall with slight shaping, but leave this as simple lines at the moment.

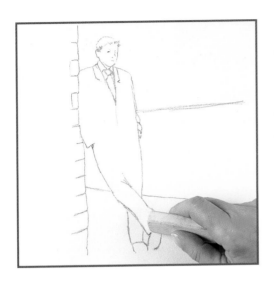

2 Erase your initial guidelines. This picture is not about capturing detail, but more about catching the essence of the pose. Pay attention to the shapes between the legs and the wall, the shoulder and face and between the crossed legs. Drawing these negative shapes will ensure that the positive shapes are correct. Begin to draw the hair, marks where the features will go and a few angled lines on the wall to indicate the bricks.

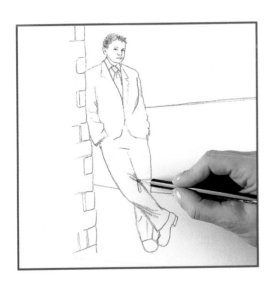

3 Firm up some of the features only after you are happy with your initial marks. Also firm up the outline of the tie and begin to mark on the shapes of the collar. Keep in mind the relationships between the head and shoulders and the arms and legs. Folds in clothes help to reinforce these relationships and, although you don't need to draw every fold you see, some are valuable to the overall drawing. Suggest the folds on the sleeves and trousers with a series of bumps on the outside lines then use rapid strokes to indicate the directions of the folds.

4 Use a few light lines to mark in the jacket. These are all curved lines, creating soft shapes on the edges of the figure's clothes. These fold lines show how the subject is twisting, they give it life and alter it from an immobile model to a living, real person. The directions of the creases and folds relate to the gesture of the underlying form, creating tension and energy. Also use light lines to create contours of the clothes and to add details to the shoes and facial features. Lightly mark on some more diagonal and vertical lines for the brick wall.

5 Add more lines of grass beneath the young man's feet. This will stop him appearing to 'float' and will anchor him on the ground. Also add lines to his side, indicating a bush. This will draw the viewer's eyes straight into the picture and towards the subject. With hatched lines, begin to add tones on the sleeves of the jacket, on the trousers, shoes and in the hair. Note how some of the tones are darker than others and can be achieved by using the 4B pencil and slightly firmer pressure. Indicate dots on the tie and checks on the shirt, but keep these light and arbitrary and never fill in every gap with a tight, flat pattern.

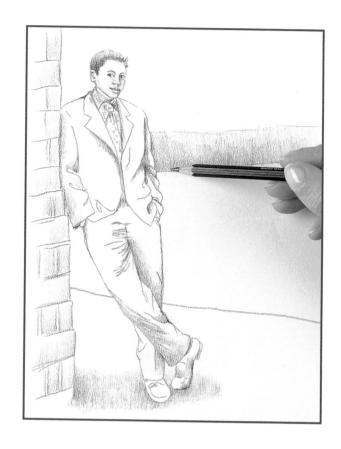

6 Although this is not a detailed drawing, some tones give it atmosphere and character, so add some further tones and details to bring the whole image together. Don't make too much of the background. Leave the brick wall sketchy and the patch of grass as a simple indication. Keep the pencil sharp and use light hatching strokes on areas of the clothing and in the hair to reinforce and add to the tones you have already marked on. Continue strengthening the areas of dark tone where the clothes fold and crease, around the tie and on the face. Keep the facial features light – you will find it easier to draw the entire face with the 2B pencil rather than the 4B.

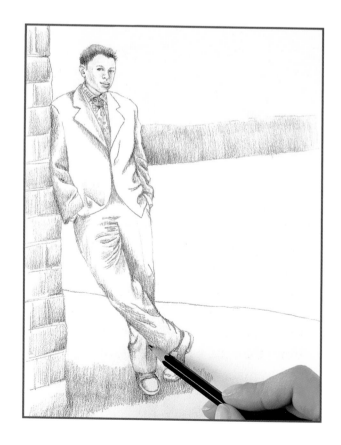

TRY A DIFFERENT ...

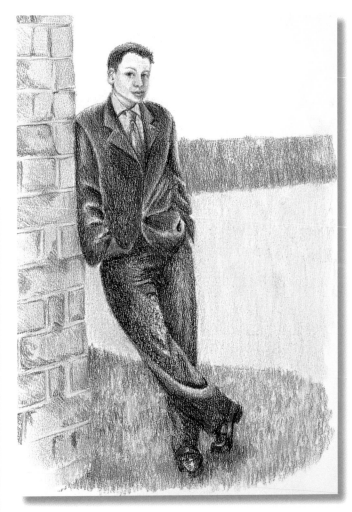

... MEDIUM

This alternative drawing in pastel pencils adds colour but few details. As with the graphite pencils, the basic shape was drawn first, then the folds and creases on the clothes were marked on to give the drawing a sense of movement and life. To create a sense of three dimensions, the contrasts of tones and highlights have been kept strong. The young man is wearing a dark suit, so the colours and shades were built up with three colours: black, navy and mid-blue. When working in colour you should be sparing with black as this tends to deaden pictures, but here, the darkest tones need to be strong. The brick wall was drawn lightly to give the picture interest and the background suggested with shades of green.

... POSE

These two friends are standing upright, with few difficult or tricky areas. Draw them as simple outlines to begin with and then fill in further details. Don't attempt to draw detailed features until the figures are in proportion and you have marked on some of the angles and curves in their clothes. Make sure that the figures are in stronger tones than the background, which should be light and soft to make it appear to recede.

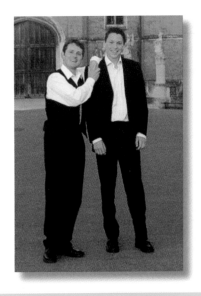

Demonstration 3

People on holiday
Pastel pencils

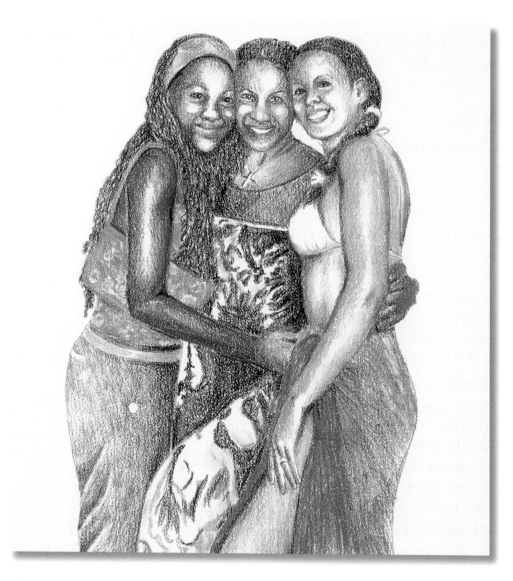

Pastel pencils can be expressive and colourful and you can use them in several ways. With a few strokes, you can produce light, hatched effects or you can blend and smooth your marks to create a softer finish. If you work with hatched lines, draw in various directions, following clothing folds and creases and let the pastel powder blend into

each other without rubbing or smoothing it. Colour should be applied carefully and layered where there are subtle changes of tone, and black should be used sparingly. Pastel pencils can make bold, rough marks and, like charcoal, will leave some powdered pigment on the support. For this reason, you should work with them quite loosely and

don't worry about details. Pastel pencils can be erased with plastic, rubber or kneadable erasers, but too much rubbing will damage your working surface. Keep your application light and don't overdo the shading to begin with. Remember that it is easier to add than to remove, so dab or stroke on small toned areas and blend away gently.

Subject

Because most of us have many holiday photos, they can be a great way to practise drawing people, whilst producing a picture that you or others will want to keep. These three women look happy and relaxed. They are well lit, from the upper front and are in uncluttered

surroundings. The colours they are wearing add interest for a coloured drawing. When drawing from holiday photos look for clear tones and relaxed poses. The background doesn't matter too much as you can ignore this, but it is helpful to have good lighting. This drawing builds on what you have already achieved with the last two demonstrations, so feel confident when you draw the angles and shapes. You will also gain a valuable understanding about applying colour and tone in this project.

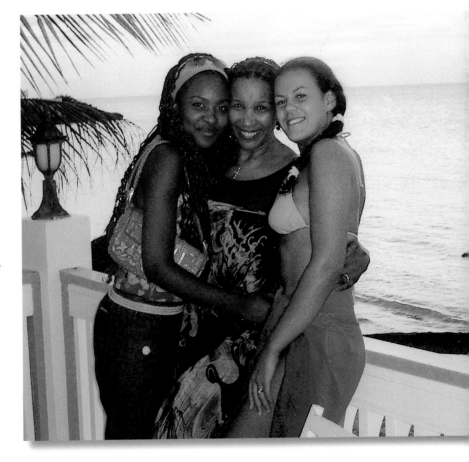

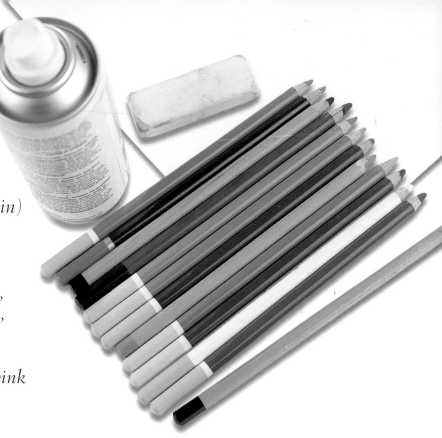

Materials

Sheet of 140 gsm acid-free cartridge (drawing) paper 420 x 297 mm (16^1/$_2$ x 11^3/$_4$ in)

Soft pencil

Pastel pencils in brown ochre, burnt sienna, raw sienna, tan, pale warm grey, ultramarine, white, cerulean blue, black, purple, soft pink and bright pink

Firm eraser

Fixative spray

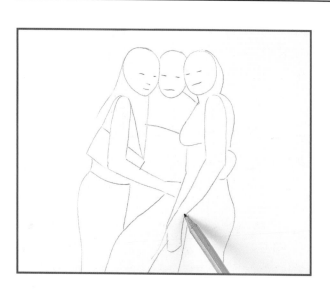

Artist's tip

When you begin to add coloured pastel pencils to your drawing, layer it carefully, allowing some paper to show through from underneath. If you don't press too heavily, good coverage can be achieved when rendering in any direction.

1 As with the first two demonstrations, look at the entire shape objectively at first, paying particular attention to the negative shapes. Then draw a simplified outline keeping these negative shapes in mind. Loosely draw the approximate outline, looking for specific lengths: the forearms, shoulder angles, heights of the heads and any spaces between them. You can either use pencil as shown here, or a fairly neutral coloured pastel pencil, such as grey, brown or blue. Graphite pencil is easier to erase, but pastel pencil will be covered up better when you add the colours.

2 Look at posture and body language as you develop the drawing, maintaining your objective view of the shapes surrounding the figures and not drawing what you *think* you see. Work over your initial simple outlines, shaping the figures and paying attention to the lengths and shapes as you see them, such as the shapes of the shoulders, hands, face and hair, and the widths of their necks and shoulders. Mark on the approximate outline of their clothes and their facial features. Gently erase your first marks as you work.

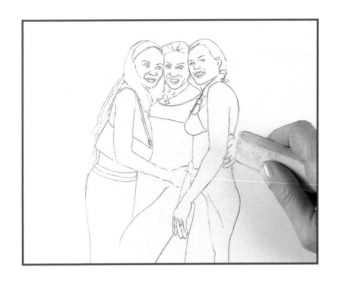

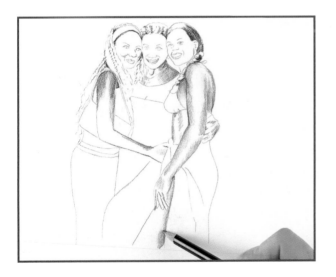

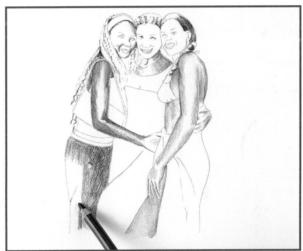

3 Begin building up the golden, bronze and brown skin tones, using brown ochre, raw sienna, tan, burnt sienna and white in light, layered lines. Look for different skin tones on each person. None of us have flat skin colours. Skin colour appears different depending on the angle of light, the shape of the limb, reflections from clothing and surroundings. Some parts of our skin are darker or lighter: for instance, necks are usually lighter toned than faces and noses are often darker than cheeks.

4 Work across the picture, building on flesh tones and only putting dark browns where the skin is darkest and leaving the paper to show through for the lightest highlights. Continue to build up the skin tones, paying particular attention to the darkest parts. Allow the pastel pencils themselves to blend the skin colours into each other. Begin applying hair: the woman with the shoulder bag has long, wiggly lines of black and the woman in the middle has small wiggles in brown and black.

5 Continue building up the hair using strokes of black, burnt sienna and brown ochre, leaving areas that appear as lighter, highlighted parts. Using a sharp point on the burnt sienna, white, tan and soft pink pastel pencils, lightly work on the facial features. Use small, broken lines on the outer edges of the eyes, cheeks and lips. Using ultramarine, shade the trousers, paying attention to the creases and applying more layers for depth of colour where the tones are darkest. Lightly shade the central woman's top in black.

6 Continue working on the faces adding further light-layered strokes to the skin tones. Layering hatched lines in different directions on top of each other blends the pastel pencil without the need for smudging. Build up the hair, emphasizing the darkest areas with small touches of black and layering lighter areas with brown ochre or burnt sienna. Using light warm grey, shade under the woman's bikini top and around the central woman's cross. Colour in the belt and hair band with cerulean blue.

7 Build up the clothes using bright pink, soft pink, cerulean blue, warm grey, black and purple. If necessary, layer the skin tones with warm grey, then tan over the top. This has the effect of softening the tan. Where you stroke purple on for the sarong, stroke only in the direction of the folds, making the colour darker and more intense at the crease of the fold. A light layer of the brightest colours will give the entire picture a brighter, fresher look. Finally, give the drawing a light spray of fixative to protect it.

TRY A DIFFERENT ...

... MEDIUM

Much of this picture is shaded, using darkest tones closest to the other people, where the light is blocked. To draw this in pencil just needs the same way of looking and some patience when shading. Pencil is a more controlled medium to use, producing a more detailed drawing. The wide range of tones was achieved with heavier or lighter pencil pressure and 2B and 7B pencils. Keep your pencils sharp and leave some highlights as blank paper – you only need to give a general idea once you've got the shapes right.

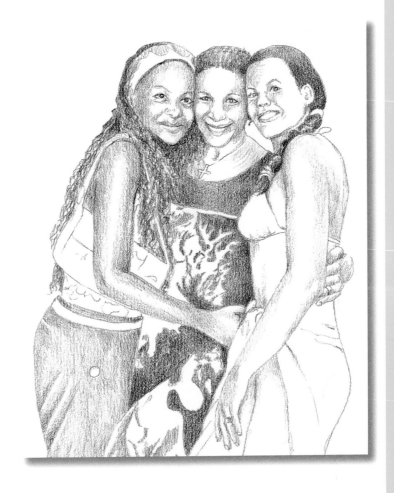

... POSE

This is another happy holiday snap that makes a delightful drawing in any medium. You could try doing a big, bold charcoal sketch or another pastel pencil drawing. Look out for both sharp shadows and brighter highlights created by the hot sun.

Demonstration 4

Child sitting *Pencils*

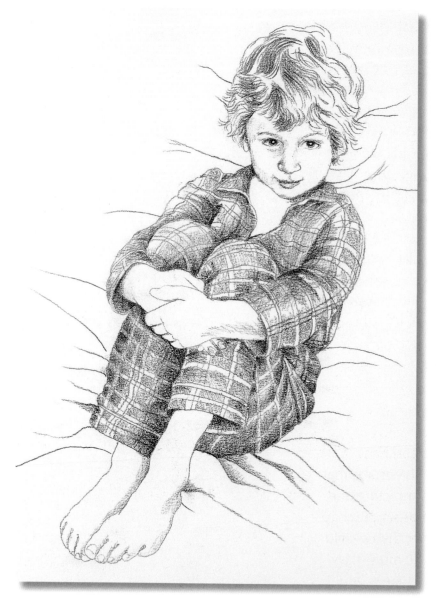

Soft pencils allow good flexibility of line and tone, depending on how you use them. Keep your wrist flexible and hold the pencil fairly far back. Vary the width of some lines and keep your tonal contrasts strong. Build up dark tones through gentle pressure, not by pressing too hard. Keep the point of your pencils sharp for detailed marks and rounder

for soft blending. You can also use a knife to fashion a chiseled tip for other effects, such as angled lines to describe 'contour' lines. These are lines that describe the inner shapes of the person you are drawing and they add to the illusion of solid form. Erasers can be used with pencils to either correct small mistakes or to 'lift' highlight out of the darks or to create texture. Pencils lend themselves to almost any kind of tonal shading, from hatching and stippling to smooth blending, but be sure not to smudge the marks with your finger as this simply creates a mucky image.

Subject

Drawing children when they are feeling sleepy before bed is a good time to catch them! At this time, they will often sit still for a little longer than usual and you can make quick sketches, gathering information that you might miss during the busy daytime. As with all drawings, keep an eye on the negative shapes and bear in mind what the completed composition will look like. As you work, you may find it helpful to turn your paper and this book around and work upside down. This ensures that you see both your picture and the photograph as simple shapes and angles, rather than a child and so you will be more likely to draw only the shapes you see, not what your subconscious tells you.

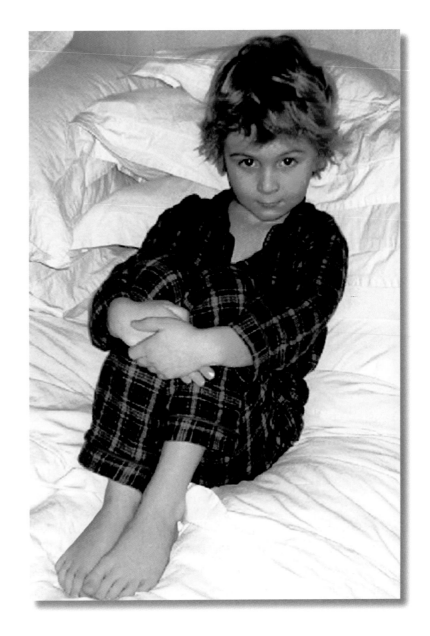

✍ Materials

Sheet of 120 gsm acid-free smooth cartridge (drawing) paper 420 x 297 mm (16¹/₂ x 11³/₄ in)

2B, 4B and 6B pencils

Firm or kneadable eraser

1 Using the 2B pencil, begin with the simple outline of the general shape, including the solid ovals of the child's legs, body and head. Be as sketchy as you like here to get the feel of the shapes and forms. Mark on the angle of the boy's shoulders, legs and arms, bearing in mind that the arms and feet are foreshortened. Draw the legs lightly as tubular shapes and mark on, in the approximate position and size, as simple geometric shapes, the hands and feet.

2 The solid shape of this boy looks straightforward, but actually includes some slight distortion in the foreshortening effects of his arms and legs advancing towards the viewer, so the hands and feet appear a little larger than you might expect. Look for alignment of parts of the body, such as his shoulders, legs and arms. Lightly draw the shapes of his pyjamas, shape the outline of the head and mark on the position of the features, erasing your initial guidelines as you work.

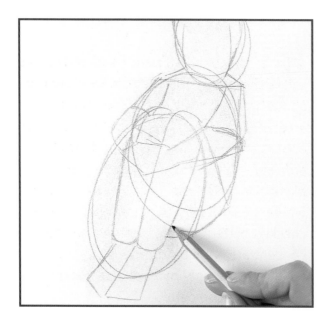

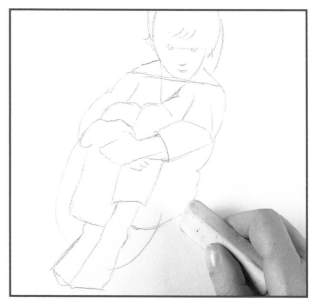

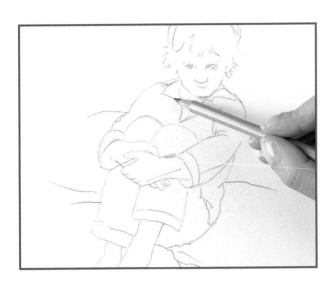

3 Still using the 2B pencil, start to shape the child's limbs, marking on toes and fingers but no details yet. Draw some scribbled creases and folds on his pyjamas using fluid lines and begin to shape the collar with lightly drawn triangles. Mark on a few soft zigzags for the hair and carefully go over the facial features, looking more at the photograph than at your paper. Draw only the base of the nose and look at the shapes of the whites of the eyes to get these shaped correctly.

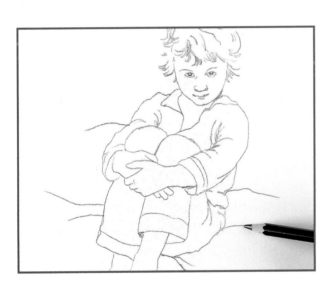

4 Still using the eraser to remove guidelines and the 2B pencil, lightly and gently go over the outline shapes, following the photograph. Add some more soft creases in the folds of the elbows and on the pyjama trousers and continue shaping the checks on his trousers and jacket. Draw the mouth and eyebrows and start to add crease lines on the surface where he is sitting. You do not need to add any more details than this for the background – these creases will simply anchor him so that he won't appear to be floating.

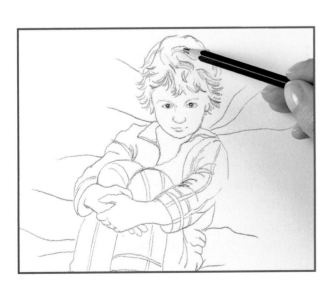

5 Change to the 4B pencil and add curves of darker tones in the hair. Don't worry about drawing every stroke, but mark on areas of dark and light with a few clusters of curved shading where the light doesn't fall and leave some areas of hair completely blank, allowing the paper to show through where the light falls. Begin to mark on the checked pattern on the pyjamas, but don't concentrate on getting this exactly right – you need to simply mark on the general idea, not precise details.

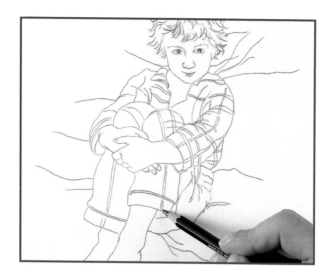

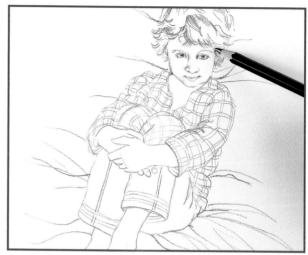

6 Continue carefully marking on the idea of the checked pattern on the boy's clothes. If you imagine the shapes of his limbs beneath the clothes, you will be able to draw the lines curving in the right direction. Remember too, that where the clothes fold and crease, the lines of the checks will disappear into the folds. Keep your pencil sharp and add some details on the face, toenails and fingernails. Leave a small circle of paper showing through the middle of the eyes for highlight.

7 Using the 6B pencil, shade the hair gently. If your checked patterning is too dark, press the firm eraser on the area and lift to lighten it. Add shading on the facial features, again, lifting with the eraser if your first marks are too heavy. Keep the entire drawing going at once – work across from the hair to the creases on the bedding he's sitting on, back to the pyjamas and over to the hands, and so on. You may need to adjust the features with the eraser as you add tone, as these are particularly light on a child.

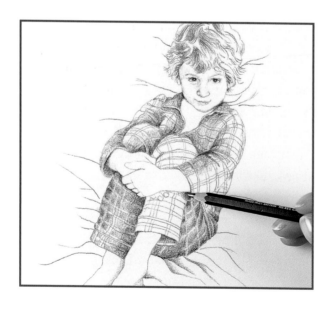

8 Once the entire outline is ready, gently begin to shade. It can be difficult to separate dark colours and tones in your mind's eye, so simply imagine where the light is coming from. For this picture, it appears to be coming from above and slightly to the left of the boy, so try to shade accordingly. The dark tones are mainly under the legs, inside the sleeves, at the back of the collar and behind the legs. Keep the 6B pencil sharp as you carefully shape and shade the face, particularly the eyes.

TRY A DIFFERENT ...

... MEDIUM

The same boy was drawn in charcoal and white chalk on beige paper. The boy is treated with fairly smooth lines and strong contrasts, while the surface he is sitting on has been blended with a finger. If you prefer, use a paper stump or torchon to blend this background. Doing this has the effect of making the figure more prominent.

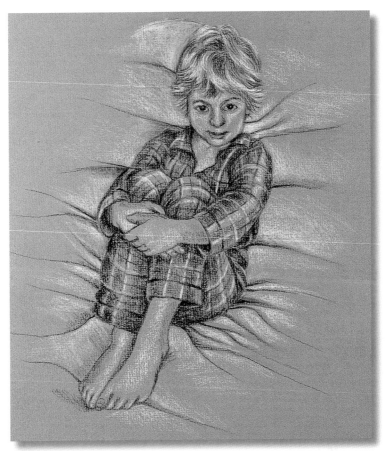

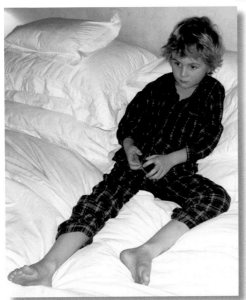

... POSE

The same boy is eating a biscuit and has stretched out his legs. Beginning in the same way as you drew the first picture, look especially for the negative shapes as always, but also the creases in the clothes, such as spiral and zigzag folds. Note that where clothes fold and crease, the light is usually strongly contrasting, that is, highlight lies next to the darkest creases.

Demonstration 5

Girl dancing *Charcoal and chalk*

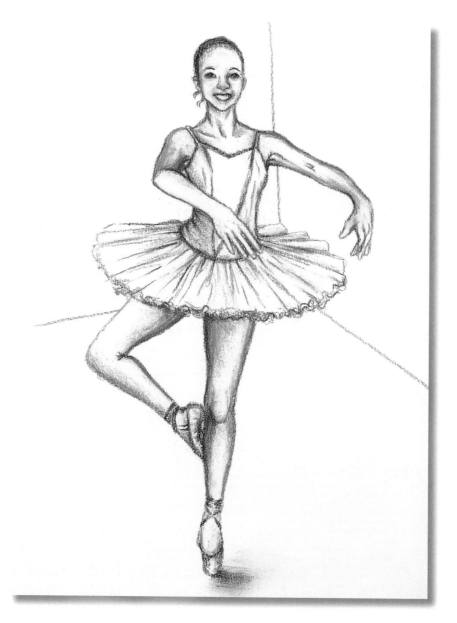

Using the black of the charcoal and the white chalk, you will be following a traditional technique used by artists for centuries to visually describe form and tone.

The fine, powdery quality of chalk blends well with the coarse texture of charcoal. Both chalk and charcoal respond well to gentle pressure, blending with a torchon or your

finger, or by laying white chalk over darker tones. If you use coloured paper rather than white, areas of mid-tones can be described with the paper itself. If using white paper, leave clean areas to indicate bright highlights where necessary. Charcoal pencils will leave your hands cleaner than stick charcoal and they can be sharpened more easily, but they usually have a harder texture. Use them for areas where you want more detail. Stick charcoal, on the other hand, while not able to create small details, can be blended well. To an extent, most charcoal and chalk can be erased, smudged or layered.

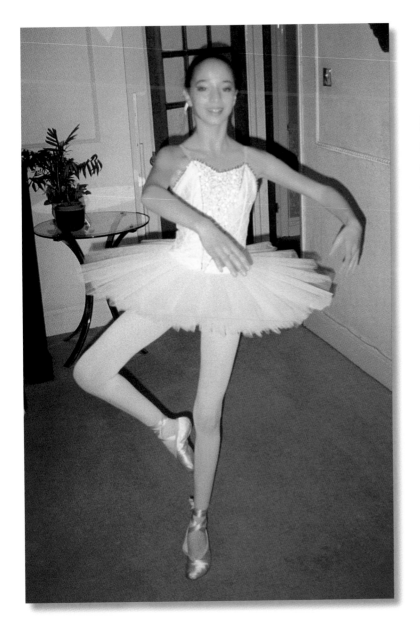

Subject

Dancers have great command of their bodies, making them excellent subjects to draw. This photo, like a modern-day Degas picture, shows the joyful movement of a young girl dancing. To draw this picture, apply light marks and retain sensitivity to both the medium and the subject. Once you have laid down the basic outlines and proportions, try to make your lines as fluid as you can to give the impression of immediacy. Using these materials ensures that you don't draw too many details, but will keep the image looking spontaneous and will give the impression of vitality and movement.

Materials

Sheet of 120 gsm acid-free smooth cartridge (drawing) paper 420 x 297 mm (16¹/₂ x 11³/₄ in)

2B pencil

Stick charcoal

White chalk

Charcoal pencil

Fixative spray

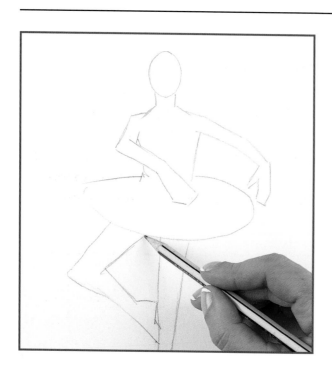

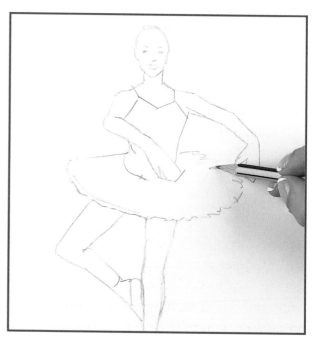

1 If you begin a figure drawing by drawing the head first, you will probably make it too large. So, look for the negative shapes around and between the body and use these to help you ascertain the structure of this pose. In a moving pose like this, look for directional movements between parts of the body and concentrate on how these portray liveliness and energy.

2 Continue drawing with the 2B pencil. By drawing the supporting leg first, you are anchoring the subject on the ground and will give your drawing balance. In the same way, draw the stretched side of the body before you draw the curved side. Try to capture the figure's rhythm as you adjust your initial marks, using an eraser where necessary and redrawing more fluid lines.

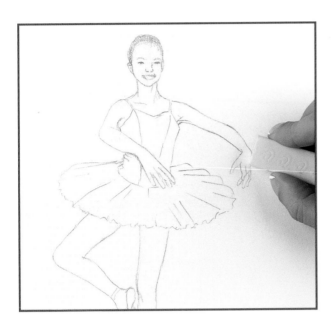

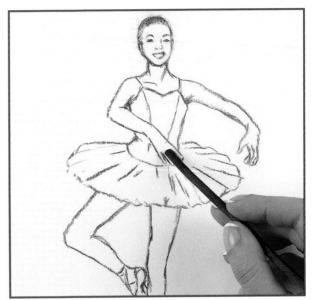

3 An initial pencil drawing is helpful if you are new to drawing. Lightly mark on the facial features and add a few lines to give the impression of the net of the tutu. Mark the shapes of the hands, looking only at the general shape, and don't worry about specific details at this stage. The right hand appears quite large as it is foreshortened.

4 Take a stick of charcoal with a fairly pointed tip and follow your pencil outlines carefully, using light pressure and broken lines. You can erase your pencil lines if you wish. Keep your elbow and wrist flexible to give light and sinuous lines. There is not a lot of foreshortening here, so most features look as you would imagine them.

5 Still using the tip of the charcoal, add squiggles at the edge of the tutu. Draw the dark shadows on the ribbons of the ballet shoes and leave the highlighted parts untouched, letting the white of the paper imply shine. Do the same with the centre of the bottom lip. For the details of the facial features, use a charcoal pencil or sharpen the tip of your charcoal stick by rubbing it on fine sandpaper. To blend these features, use a torchon or the tip of a stick of white chalk, which will have a similar, softening effect.

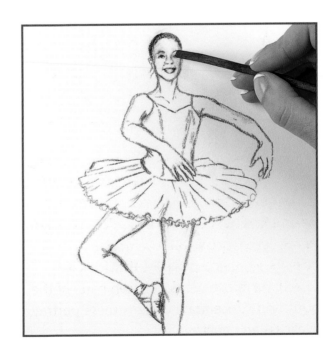

6 To show movement, add two small squiggles by the girl's right ear to indicate pieces of ribbon fluttering. Using the fine tip of the charcoal pencil, delicately work up the facial features and add tones to the neck, shoulders, arms and legs. Don't overdo this as the picture needs to remain light and flowing, to imply youth and the spontaneous impression of dancing. With the 2B pencil, lightly mark on where the floor meets the walls – deliberately diagonal to give an even greater image of movement and life.

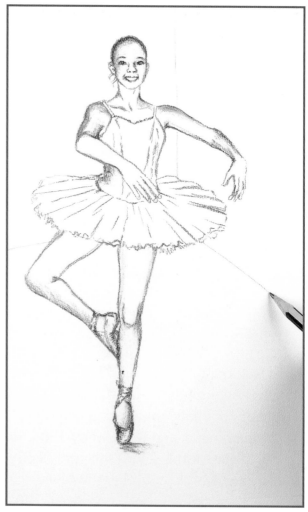

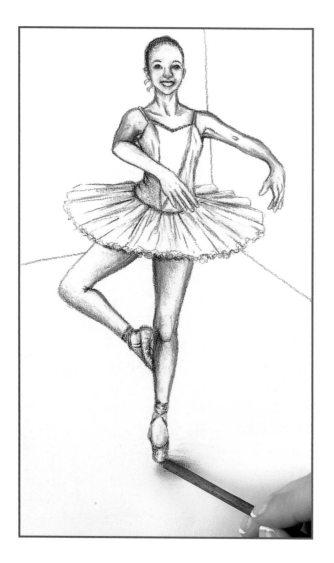

7 Using the white chalk, add some highlights where you see them in the photograph and also use the white to spread and blend black charcoal to grey mid-tones. Check over your picture – stand back and look at proportions and tones. If you have made any errors, press and lift a kneadable eraser on that particular area. Continue using the white chalk to blend and smooth the tones but don't overdo this and leave plenty of paper showing through for the brighter highlights on the face and on most of the tutu. Spray your finished drawing lightly with fixative sray.

TRY A DIFFERENT ...

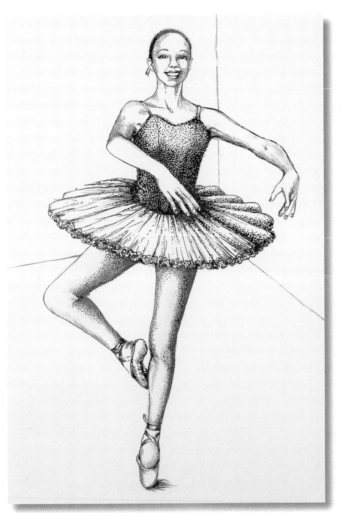

... MEDIUM

Try drawing the same image in pen and ink. Begin as you have been with a light pencil drawing and then use a dip pen, fine nib and brown ink. When drawing with the ink, only use the pencil marks as a guide and don't follow them in one continuous line; use broken marks and keep things light. You can always add more marks, but you can't take any away. Use the lightest hatched or stippled marks for a suggestion of darker tones.

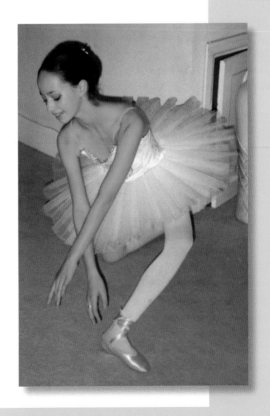

... POSE

The same girl is making a graceful sweep to the floor, crossing her arms and bending her legs, but keeping her back straight and her chin tilted upwards proudly. The only problem you might encounter here is making the back leg look like a leg! It is bent and pointing towards the back, so you might have to emphasize the slight angle by adding stronger tones around the knee. You won't need much background with this picture, so as before, simply mark on the diagonal line where the floor meets the wall.

Demonstration **6**

Wedding group
Range of pencils

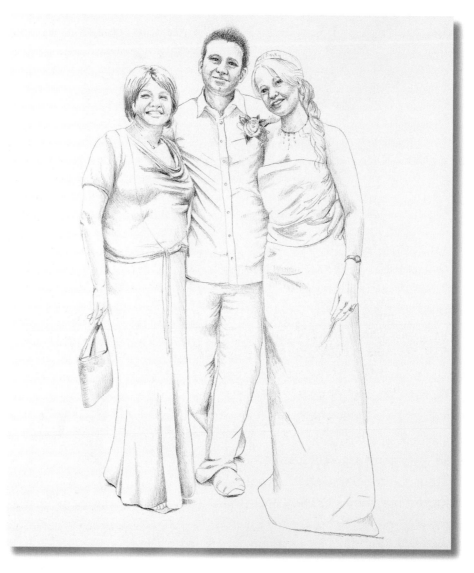

Soft pencils are possibly the easiest materials to use because most of us begin drawing with pencils from an early age. Using a range of soft pencils, you can produce a large variation of tones with little adaptation to your drawing technique. Use well-sharpened pencils, keep your elbow relaxed and try not to tense your arm or shoulders. Keep your

wrist flexible and hold the pencil fairly far back. By varying the pressure you apply with your pencils, you can build up a range of tones, from palest grey to darkest black. It's important to learn how to represent tone convincingly in order to give your two-dimensional drawing a three-dimensional appearance with a clear sense of height, width and depth. Tone is affected by the way the light falls on objects or people; if it falls from a sharp angle, it will create acute tones, if it falls softly, it will cast gently modelled tones. Tone can create mood and atmosphere. To make light tones, use lighter pressure and vice versa. Always build tones from light to dark, as it is easier to make a light tone darker.

Subject

This group of people are standing in bright sunlight, so the tones contrast strongly. Because the bride and groom are in white, the tones on their clothes are softer than the tones on their faces, but be aware that even white has a range of tones and shades and the darkest tones can still be visible on the lightest of surfaces. This is one occasion when you can draw lines beneath people's eyes and simply make them look happy – not tired or old – but keep a light touch or you'll end up adding twenty years to your models' faces! The single strong light source also helps to define the shapes that the three figures make and shows off the simplicity of the composition.

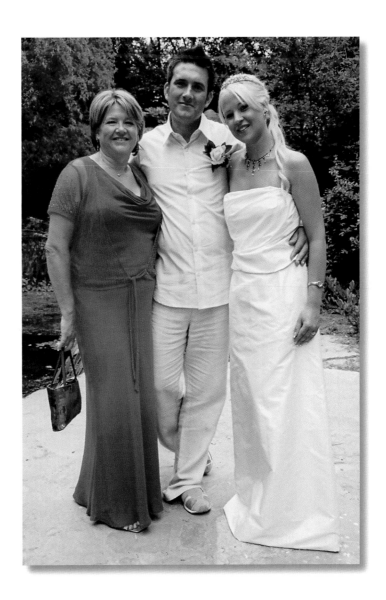

Materials

Sheet of 120 gsm acid-free smooth cartridge (drawing) paper 420 x 297 mm (16¹/₂ x 11³/₄ in)

2B, 3B and 4B pencils

Kneadable eraser

1 Using the 2B pencil, sketch the outlines of the figures. Try to draw them in proportion and in relation to each other. Work lightly as you will eventually be making the tones more prominent than the lines. Compare the distances between the heads. Notice how the two women complement each other – they are almost the same height and are turning their outer shoulders towards us. Roughly mark on the lower parts of their legs and dresses. Look for angles and simple geometric shapes and don't even consider tones yet!

2 Once you are happy with the initial simple shapes, still using the 2B pencil, start shaping the figures using curved lines and begin marking in some details, including sleeves, necklines and hands. Your lines should describe the shapes of the figures as you see them, so take care as you alter the straight lines into curved ones. Use light, broken lines for this and go slowly, studying the photograph as you draw. Start to mark on the facial features, the bride's watch and some creases in her bodice.

3 Continue to sketch in linear details, such as the flower on the man's shirt, but leave the tones aside for the moment. As you draw, pay attention not only to the shapes of the people, but also to the shapes created around and between them. These negative shapes are as important as the positive shapes of the figures as they ensure that you get the balance and composition. Look for overall shapes of hair, particular shapes of clothes and the distances between and around the facial features.

Now, using the 3B pencil, begin establishing the tones, marking them on lightly where the clothes fold and crease. Apply these tones lightly for now, looking to gain a balance across the entire picture. So, shade under the people's chins, around their arms, torsos and shoulders. Keep this shading in small areas for now, until you feel confident about where you are positioning it and how strong it should be.

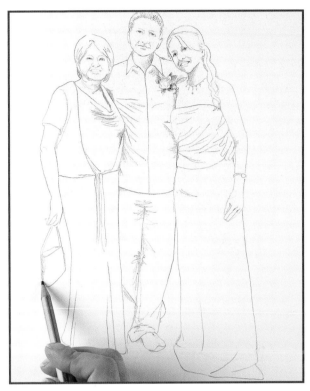

4 Still with the 3B pencil, darken some of the tones where they appear darkest on the photograph: under some of the hair, around the base of the people's necks, between the man's legs, under his front foot and in the creases of his shirt. Notice how the creases on the figures' clothes appear to twist and splay as they move and turn their bodies. The darkest tones fall under these creases, while the light falls immediately above the darkest tones – on the fullest parts of the folds.

Artist's tip
When creating a tonal drawing like this, make sure that your initial linear sketch is detailed, but keep the lines light as they should not be too noticeable once the tones are applied.

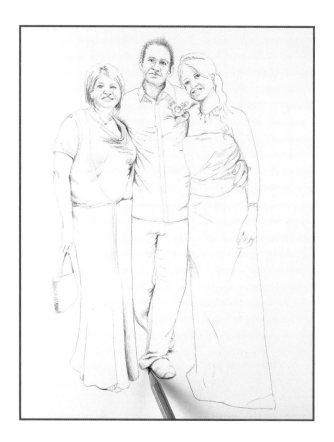

5 Using the 4B pencil, try to shade in the 'correct' direction; that is, horizontally or diagonally on the clothes and bag, to help to describe the way they fall or are made. Keep looking at the photo to assess where the darkest and lightest tones appear and gradually build these up across the whole drawing, extending these tones across the figures or blending them away as necessary. Lightly shade the facial features before you draw them on using the sharp tip of the pencil. Also with a sharp pencil, mark on the man's shirt buttons, shadow on the handbag, watch and necklace and the corsage. Make sure that you only shade on the faces where the light does not fall.

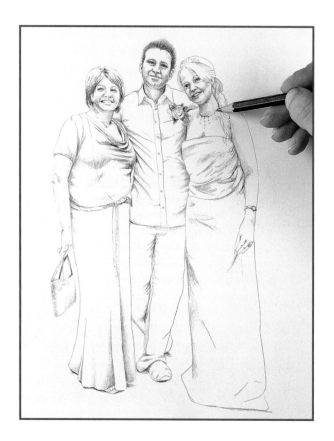

6 Carry on gently shading across the entire drawing where you see soft tones on the photograph. Compare your drawing to the photo. Do the figures stand solidly in their own area yet connect through the negative shapes between and around them? Do your tones help to make the figures appear three-dimensional? Have you kept your pencil sharp and do your details stand out, while the tones blend almost to nothing where necessary, implying soft fabrics, hair or skin? If not, erase any errors and correct them. This is not a photo, but a tonal drawing, so if you've answered yes to only some of these questions, then your drawing is a success!

TRY A DIFFERENT ...

... MEDIUM

This same photo was made using a limited palette of coloured Conté sticks. The limited palette allows for a certain amount of colour to be introduced to enliven the picture, but there aren't too many elements to confuse you or your main focus. This drawing was made in much the same way as the pencil drawing, but because Conté is chalkier and thicker-tipped than pencils, it contains fewer details. To draw this picture in these materials, half close your eyes when looking at both your drawing and the photograph at frequent intervals to compare the tones and make sure that all the tones are relative to each other.

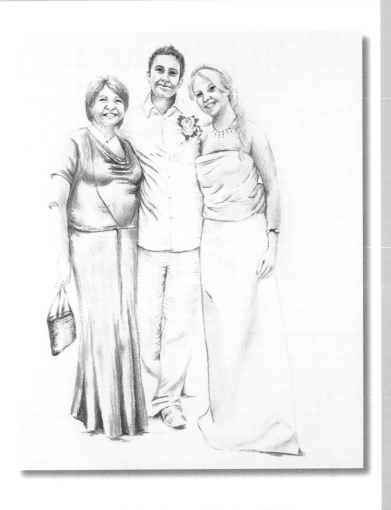

... POSE

A black and white photo is one of the easiest ways to see tonal variations. This happy picture of the bride and groom will make a delightful drawing and if you use pencil, graphite sticks or charcoal you will be able to create the range of tones as you see them here. To make the whiteness of their clothes stand out, add some darker shading to the background.

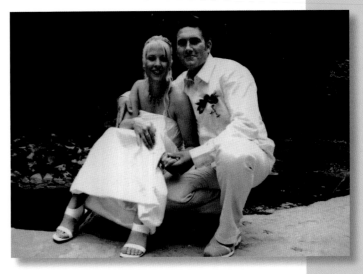

Demonstration 7

Children playing *Pastel pencils*

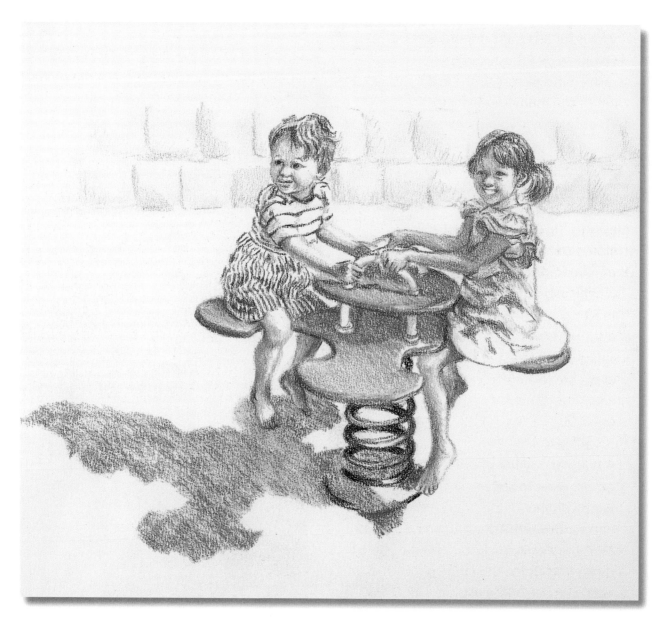

A few strokes of pastel pencils can create expressive drawings and you can blend colours on the paper as you apply them. Try to keep your drawing light, allowing some of the paper to show through. If you apply heavy colour, you will restrict your ability to add in tones and textures. It is a common mistake to 'block-in' colour when using

coloured materials, which can deaden any other effects. Although pastel pencils come in a variety of colours, resist temptation to use too many to begin with and maintain the 'less is more' adage. Keep your drawing sketchy and light – you can always add more colours to build up depth or definition as you work. The colours can be blended with a torchon to achieve a smooth appearance, but leave some obvious lines and marks to give character to the picture, such as for the clothes and hair. Remember too, that this medium is difficult to erase although you can layer colours to 'blot out' mistakes in some cases. Also, try ranging your marks between longer and shorter strokes.

Subject

Create a soft and natural picture of children playing – capturing children can be easier than you might think! The difficulty with this image is the foreshortening of the children's legs and the angles at which they are holding on to the seesaw. So the best way to begin is to look at them as two shapes and, as usual, look for the negative shapes as you begin to draw. Even if your proportions are slightly wrong, by adding the shadows and tones where they appear in the photograph, your drawing will come to life.

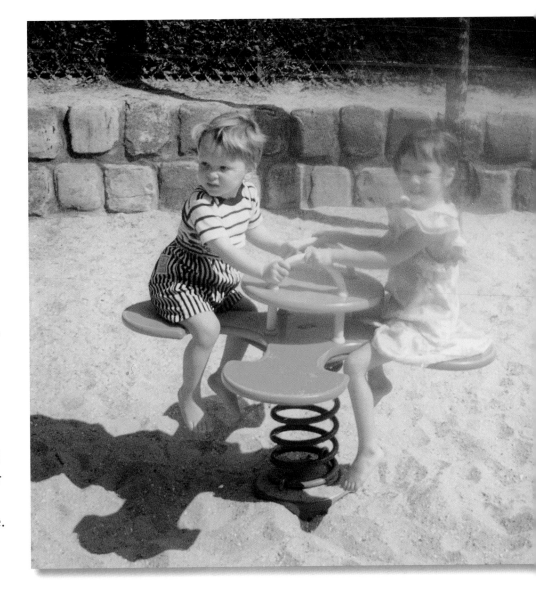

Materials

*Sheet of 120 gsm acid-free
smooth cartridge
(drawing) paper
420 x 297 mm
(16¹/₂ x 11³/₄ in)*

2B graphite pencil

*Pastel pencils in
indigo, Prussian blue,
yellow ochre, burnt sienna,
orange, flesh, light brown, brown,
mid-grey, dark grey, light grey*

Kneadable eraser

Fixative spray

Artist's tip
If you mark on the angles of the shoulders and hips early on, you will help yourself to place the limbs and to understand why certain parts of the body look smaller or shorter. For instance, the hips of both children in this photo tilt away from the viewer, meaning that the legs furthest away look shorter than the legs closest to us. A similar effect is created by the shoulders and arms.

1 Ignore the background for the time being. Using a 2B graphite pencil, place the children near the centre of the paper, keeping it the portrait way up. Begin with the solid parts of their bodies and mark these on as almost rectangular shapes. Then add an egg-shape for each head, remembering that these young children are between four and five heads in height. Mark on the limbs roughly with simple lines.

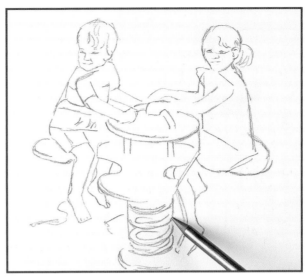

2 Still using the graphite pencil, start to shape the arms, heads and legs. Mark on their facial features lightly. Also begin shaping the seesaw, which isn't as difficult as it might look! The top part, just below the children's hands, is a simple ellipse shape. You might like to practise drawing ellipses in a sketchbook. They are just squashed circles, but once you have the knack, they are quick to draw and are useful for all kinds of objects you might find yourself drawing.

3 Add a little hair to both children and begin to sketch in the spiral that the seesaw sits on. Try to draw each part of this picture accurately, but if you make mistakes, simply erase them and draw again. If you make sure that each part fits each other, for instance, the seesaw meets the girl's dress on one side and the boy's knee on the other, then it should all balance. Because of this it is important that you keep checking parts of the image in relation with each other.

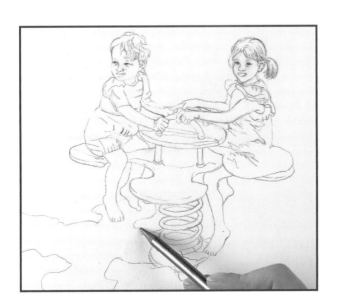

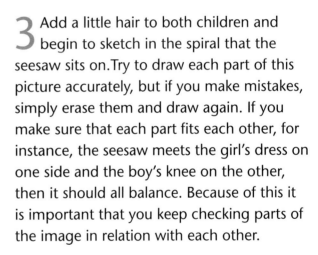

4 'Firm up' the facial features. Draw a light outline beneath the boy and the seesaw, roughly indicating the shadow in the shape of a sort of squashed cross. Now begin with the pastel pencils and using the light brown, lightly shade the areas on the children that are in shadow. Keep this colouring light and open – you do not want to aim for heavy, solid colour, but rather just a light suggestion of what is there.

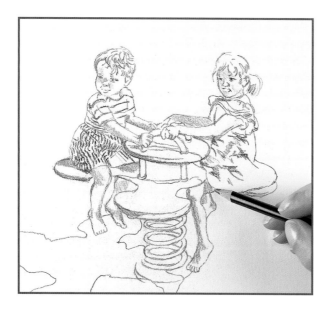

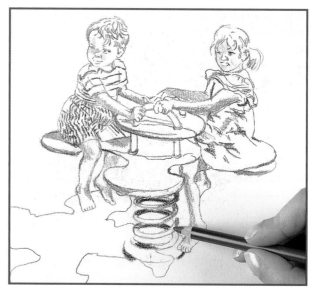

5 Begin to mark on some orange on the seesaw. The girl's dress is lightly marked where it creases with some small scribbles in the direction of the creases, using Prussian blue. Note the indigo stripes on the boy's shorts. Keep your scribbles light and broken, following the direction of the garment. This immediately gives a realistic impression. Use mid-grey to shade under the top part of the seesaw and on some of the creases in the girl's dress.

6 Where the spiral stand catches the light, use light strokes of Prussian blue, but don't worry too much if you leave small areas of the white paper showing through as this all adds to the impression of highlight and shine. Build up the stripes on the boy's clothing, ensuring they follow the direction and the form of his body correctly.

7 Build up the flesh tones, using yellow ochre, flesh, light brown and brown. Also build up the hair with some light brown streaks ensuring that areas of white paper show through as highlights. Use light grey on the boy's T-shirt, on the sleeve and down the side under his right arm as light shadow to make him look rounded. Clarify the toes, fingers, ears and facial features and mark on the handles on the seesaw with dark grey. Shade the shadowed area on the ground with grey and sketch in bricks behind the children using light brown and burnt sienna.

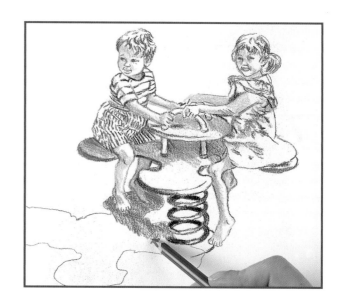

TRY A DIFFERENT ...

... MEDIUM

Here, the same children have been drawn using 2B and 3B graphite sticks. They are similar to pencils, only heavier and more brittle as they are solid graphite without the wooden casing.
This is a tighter, more intimate drawing of the children, using a wider range of tonal values. By emphasizing the tonal contrasts quite strongly, the drawing appears more three dimensional.

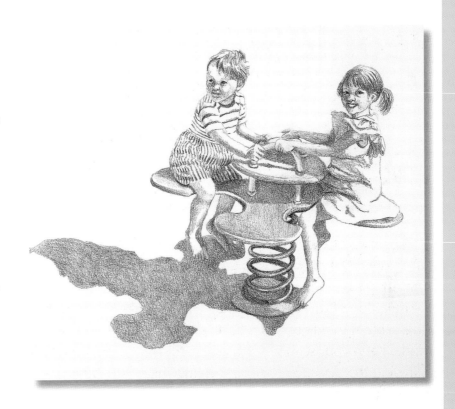

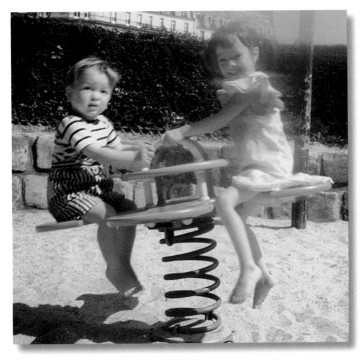

... POSE

By drawing this particularly lightly, using broken lines and perhaps hatched lines for the darker tones, you can produce a drawing that gives the impression of movement. If you want to try this, don't draw facial features too firmly, but keep everything light and sketchy.

Demonstration **8**

People in sepia *Conté*

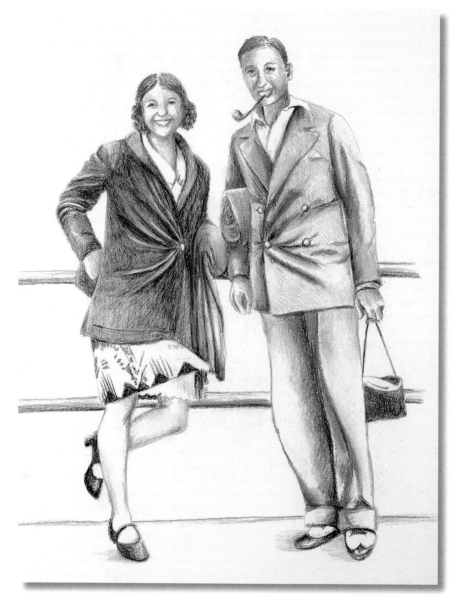

Conté is a chalk-based substance, which you may prefer using in sticks or crayons, depending on what feels most comfortable. Conté adheres to the paper more than charcoal as it is slightly waxier and so is fairly difficult to erase. Don't let this put you off, though. This is a versatile and satisfying medium to use and is available in a variety

of colours. It can make strong or soft marks, depending on the way you apply it and drawings made using it can be bold and give the impression of depth, density and texture without too many small details. A support with a texture gives the most satisfying results as the 'tooth' of the paper 'grabs' the powder of the Conté. As you begin, apply the Conté lightly until you become familiar with the feel of it. You will soon find what pressure suits you best. This is the medium that so many artists, from Renaissance to modern masters, have preferred using. Although Conté is available in many colours, in order to reproduce this picture effectively, use a limited range of colours and mix them on the paper, allowing the under colours to show through.

Subject

Many of us have sepia or old black and white photos of older relatives or people known to us and many of these old pictures make wonderfully captivating portraits. This particular photo shows how the relaxed stance or movement of the figures affect the drapery of the clothing and cause their clothing to crease and fold. The loose jackets and draped coats hang from the shoulders and arms and the creases indicate the twists and turns of the bodies beneath. The drape and flow of their clothes help to indicate the direction of the body movement. It is a relaxed and informal moment in time that works well as a drawing.

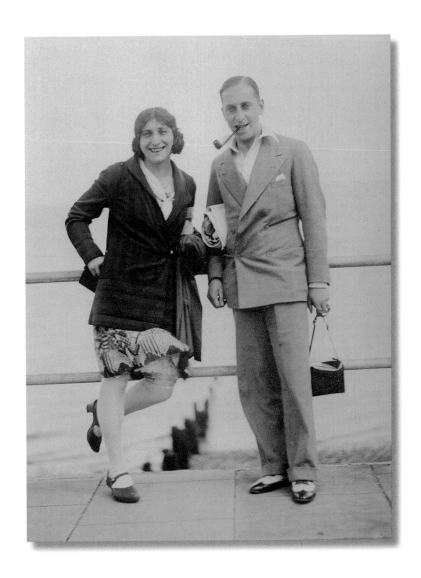

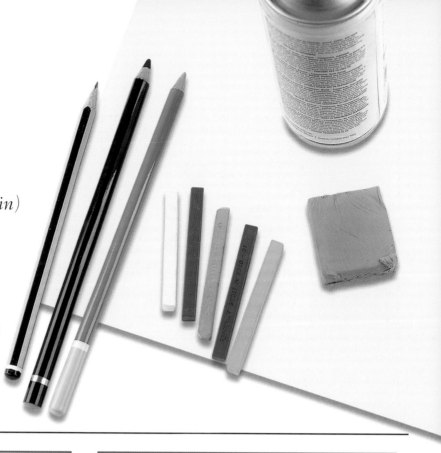

Materials

Sheet of 120 gsm acid-free cartridge (drawing) paper 420 x 297 mm (16¹/2 x 11³/4 in)

2B pencil

Conté crayons or sticks in sepia, sanguine, black, grey, white, orange and brown

Kneadable eraser

Fixative spray

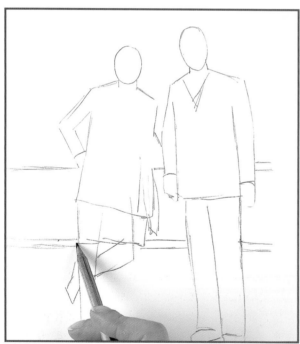

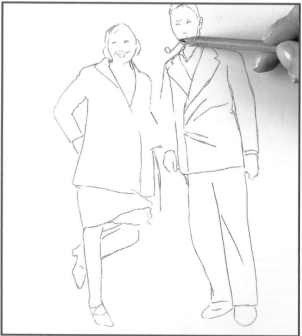

1 There is a distinct difference between the shape of the man and that of the woman. Note these differences as you draw the initial angular shapes of the two people using the 2B pencil. You are looking at widths between them and angles of the parts of their bodies in comparison to others.

2 Now make light, long strokes with the same pencil, shaping the rounded areas of the people. If you can't keep your lines steady, make small dashes to shape the two figures and the contours of their clothes. Mark on the woman's shoes, the hands, the man's pipe and facial features.

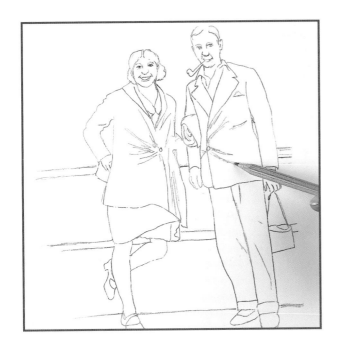

3 Use the pencil to build up the picture. Take care to look at the photo more often than you look at your drawing – even draw while your eyes are on the photo. Look at the swirls of the coats they are carrying rolled up under their arms and lightly draw them. Add smaller, more carefully drawn folds and creases on the clothes. The folds span out from the buttons on their jackets.

4 Using the brown and sanguine Conté, begin to establish the darker mid-tones on the jackets, hair and man's trousers. If using sticks, your fingers will get dirty, so you might want to use a torchon or piece of paper towel to spread and blend these tones. To keep the tones even all over the picture, also use the grey Conté on the bags, woman's shoes and under her hair.

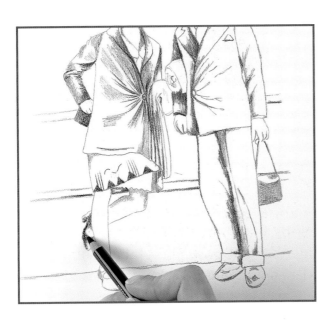

5 Continue working with these three colours, building up the 'sunray' effect of the woman's jacket and adding details to her skirt. Then, using the black Conté, add accents in the places where the darkest tones are, including where the woman's jacket buttons up, on the folds of her sleeve and on her bag. Light, feathered strokes of grey on the man's trousers and sleeve, on the woman's leg and in more concentrated hatched marks on her jacket help to build up the overall effect of tones and textures.

7 To build up the darkest areas of the woman's coat, layer small grey marks in different directions, with less layering on the lighter areas and none at all on the lightest parts. Keep working the brown on all parts of the two figures, but particularly on the man's clothes. Use either a torchon or piece of paper towel to blend colours into each other, or use the white Conté over the lightest and mid-tones. Shade the bars behind them.

Artist's tip

When blending light into dark or vice versa, by layering with white Conté, you will amalgamate the colours beneath, allowing the colours to remain fresh and not as softened as they would be if you blended with a torchon or your finger.

8 Once you have established the creases and folds in the clothes and the different tones, add some details to the faces and hair. Shade the man's pipe and add light decoration on the shoes and woman's skirt. Add more black for the deepest accents, particularly on the woman. Build up brown marks on the man's clothing, but resist temptation to fill in blocks of colour. Handle the Conté lightly and in small patches. This is a fairly well defined drawing so leave most areas unblended.

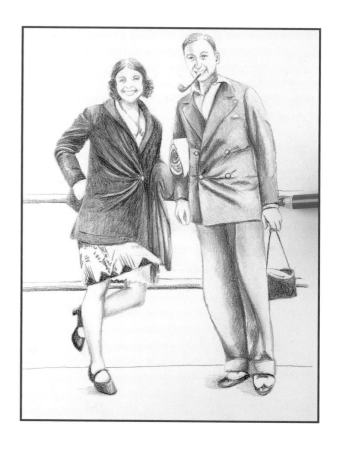

TRY A DIFFERENT ...

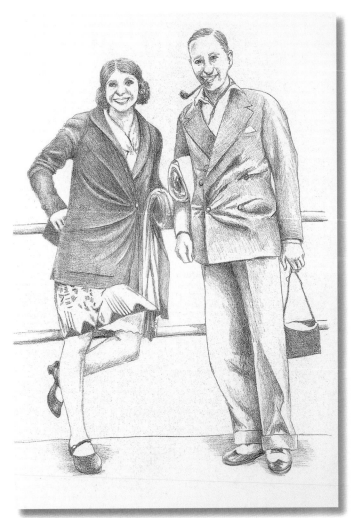

... MEDIUM

Drawing the same image in pencils means that you can build up tones and details as much or as little as you like. Once you have drawn the outlines lightly, comparing distances and angles between the figures, begin to draw in details using a sharp B or 2B pencil. Then add light tones in a softer pencil – 3B or 4B – and layer these tones where you need the darkest areas, gently easing off the pencil pressure and layers of rendering where the tones are not so strong. This drawing requires plenty of patience as the details and range of tones are built up slowly and carefully.

... POSE

This charming photograph of a young woman and boy is a fairly straightforward pose, with little foreshortening. You might like to try drawing it on cream paper with Conté or coloured pencils. You could even try drawing either or both of these photos in coloured pencil or pastel pencils, bringing them vividly to life. A word of advice when drawing glasses: don't press uniformly all the way round the rim, but leave areas where the light shines.

Demonstration 9

People sitting *Coloured pencils*

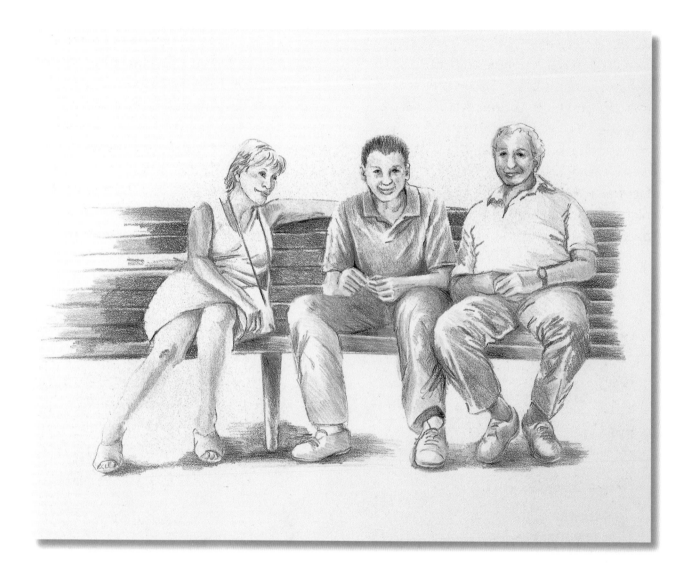

Coloured pencils do not blend as easily as graphite pencils and chalk-based materials, but the colours can be layered to create a variety of colours and effects. Try blending them on the paper as you work, or burnish them – a technique similar to blending but with firmer layering – on top of each other, producing an almost paint-like density. You can shade with hatching or cross-hatching or by rendering with small, elliptical movements to cover the area completely. Don't press too hard – add more layers if

you want to make a deeper colour and try layering lighter over darker and vice versa for a variety of effects. Try to look at skin tones objectively. Whatever the colour of our skin, we all have several tones within it – none of us have a mask-like single colour, we all have patches of completely different tones and tints. So don't just assume that all areas of skin are uniform, but look for the lights and darks and colour them accordingly.

When working from a photograph or print, feel free to omit anything you feel spoils the picture. Here, the unsightly carrier bag has been left out altogether.

Subject

These three are relaxed and calm, at ease with themselves and each other. It's a balmy day under the cool dappling of the trees. So how can you show the individual character of the people you are drawing, while making the group look comfortable and coherent? Look at the poses of each person and define the negative spaces around them, seeing where they connect and what shapes the spaces between them make. If you see the entire group as one shape, a series of angles and contours that creates a solid image, you will build up a strong compositional relationship between the people.

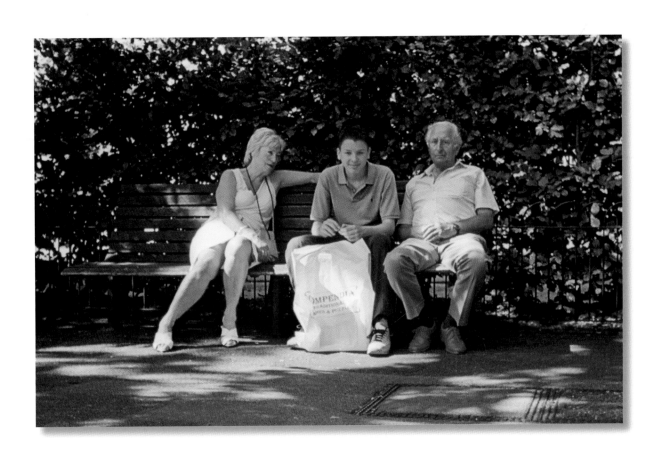

⟿ Materials

Sheet of 120 gsm acid-free smooth cartridge (drawing) paper 420 x 297 mm (16¹/₂ x 11³/₄ in)

2B pencil

Coloured pencils in dark blue, light blue, mid-blue, flesh, raw sienna, light brown, dark brown, warm grey, dark grey, light grey, yellow, lemon and pale green

Firm eraser

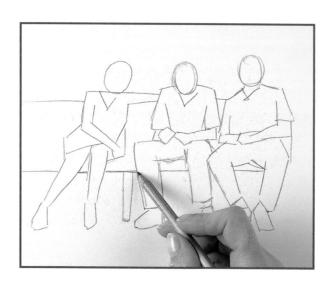

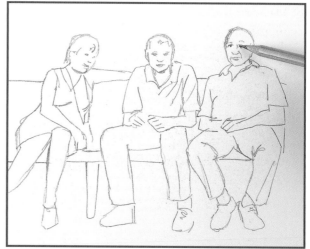

1 Begin by marking the rough outlines of the entire group, seeing the three people and the bench in relation to each other and keeping the lines angled and simple. Use a soft, 2B pencil for this so that you can erase any mistakes. Omit the carrier bag for this drawing. Keep this initial drawing fairly large on the paper, not too small so that you end up with too much white space around them.

2 Still using the 2B pencil, once you have established the angles and distances between forms, start to shape the outlines, keeping your pencil pressure light and erase the initial angled lines as you go. The difference with drawing single figures and groups is that the group has to look 'comfortable' with each other and to make a complete picture, rather than a disjointed collection of people.

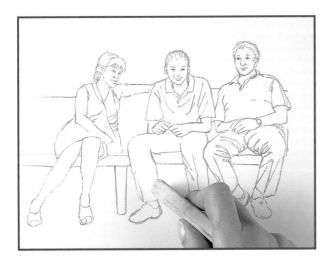

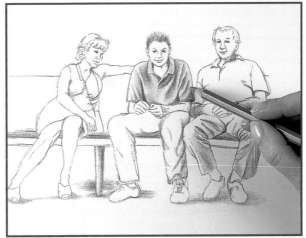

3 Now you can begin to build up the image as actual people. So far, you have simply been establishing proportions and shapes. You should now begin to draw the shapes of the clothes, facial features and legs as you see them on the photo. As you draw, concentrate more on the photo than you do on your drawing. If you look too much at what you are drawing, your subconscious will take over and you will end up drawing what you think, not what you actually see. Carefully mark on the positions and angles of the facial features. Erase your earlier lines.

4 Once you are satisfied with the outlines (check head heights, distances between feet and shoulder angles) select a mid-blue coloured pencil and shade the darker areas of the boy's T-shirt. Note that these deeper tones are diagonal and moving upwards and away from his body. Strengthen these with a darker blue pencil and shade between with light blue. Do a similar shading effect on the man's trousers with warm grey and 'anchor' the feet on the ground with some light, horizontal shading in the same colour. Also shade the leg of the bench between the woman and the boy with dark brown.

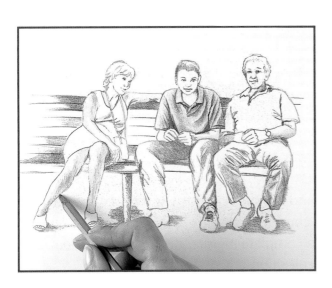

5 Continue deepening the darkest blue tones on the boy's shirt using a sharp-tipped dark blue pencil. A little blue on the woman and man's shirt where they reflect the boy's T-shirt will help to hold the composition together. Horizontally colour in parts of the bench in dark and light brown to give the effect of the grain of the wood. Closely observe where the flesh tones are deepest and begin to colour these in on the woman's arms and legs.

6 Build up the flesh tones, leaving the paper showing through where the light touches them. Using the three shades of grey, add details and shadows to the faces and clothes. Build up the boy's hair using short vertical strokes. For the man's shoes and shaded areas of skin, use raw sienna in small, careful shading. Dark brown marks in the woman's blonde hair helps to establish shape, on which you should then layer some lemon streaks, but leave some paper showing through for highlights.

7 Using the three shades of grey, softly shade here and there across the picture. Using the same tones will help to hold the group together. Layer greys over browns where you want deeper, darker tones and use light grey gently for the tones in the woman's white dress and in the man's hair. Build up more brown tones on the man's shoes, dark grey on the boy's trousers and the strap of the woman's bag. Don't forget to add warm grey under the chins and in the creases where they fold their arms.

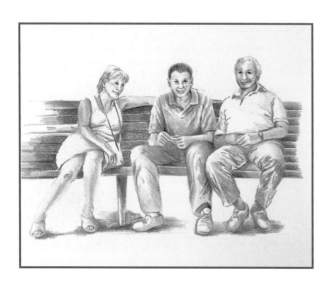

8 Look at your drawing objectively. Notice where you need to strengthen the colours and tones and put these in. With a sharp grey, brown, blue and flesh, strengthen the facial features, including ears and hair. Add lemon and pale green to the woman's top and the man's shirt respectively and add deeper horizontal strokes of grey beneath the feet.

TRY A DIFFERENT ...

... MEDIUM

Using a single nylon-tipped black fine line pen, try drawing the same group of people. Fine liners enable you to make strong linear marks, but tones can't be blended. Instead, build up some tones using hatched, cross-hatched and stippled marks as and where you need them. For a drawing like this, keep things medium-sized and not too large as it takes time to build up the toned areas. Note that some areas are deliberately left white even though there are some tones in the photo. This is to keep the drawing light and fresh and to avoid it becoming heavy and overworked.

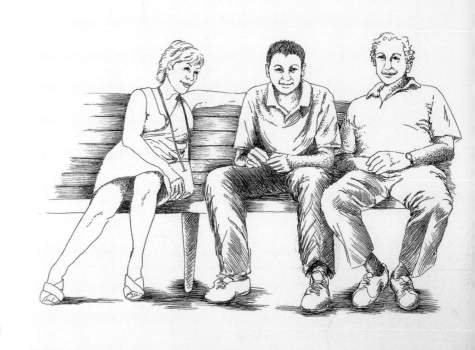

... POSE

The variation on this theme is endless. Try drawing the same people in this photo. It is similar to the first picture, but the people have moved slightly. No one is looking at the camera, but all three remain relaxed and in a well-composed group. You could add some of the foliage around their heads this time. If you do, simply squiggle general shapes and don't try to draw individual leaves.

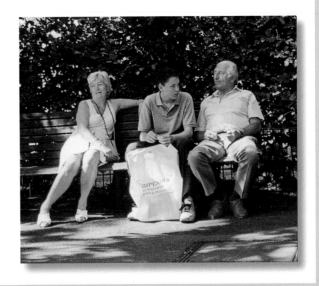

Demonstration 10

Family group *Line and wash*

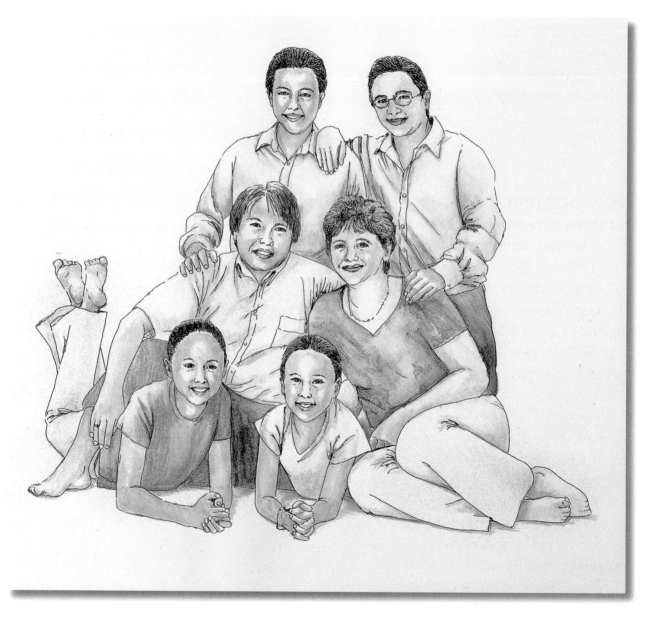

Pen and ink drawings can be as detailed or as loose as you wish. Smooth paper will give you a good deal of flexibility and control and a fine nib will allow you to include intricate marks. As ink can't be erased, start with a pencil sketch. Once you've established the outline, colour can be introduced with watercolour or water-soluble coloured

pencil washes. These washes can be as light or as heavy as you wish, but if you are using a lot of water, you will need to work on thick or stretched watercolour paper. Thin or lightweight paper will buckle and cockle if you apply too much water. Never feel that a 'finished' drawing has to be particularly elaborate in order to be effective. For drawing people, one of the benefits of using line, or pen and wash is that you can blend and soften outlines, creating movement and vivacity and softer, blended tones that aren't possible with just pen and ink drawings. Both waterproof and water-soluble inks have their advantages, but bear in mind that waterproof ink cannot be reworked. A dip pen, ink, water-soluble coloured pencils and a brush are used together in this drawing to bring together all the elements of proportion, structure, tone and composition.

Subject

Two sons, two daughters, a mother and father are grouped together in an informal family pose. Although they are each separate elements in the composition, they are all linked by positions, gestures and family resemblances. The way that they are grouped together in an informal triangle or pyramid, holds the composition together and the angles of each person's shoulders, head and torsos, both echo and contrast with each other to give added interest. The colours also echo and blend with each other, giving an overall coherent image.

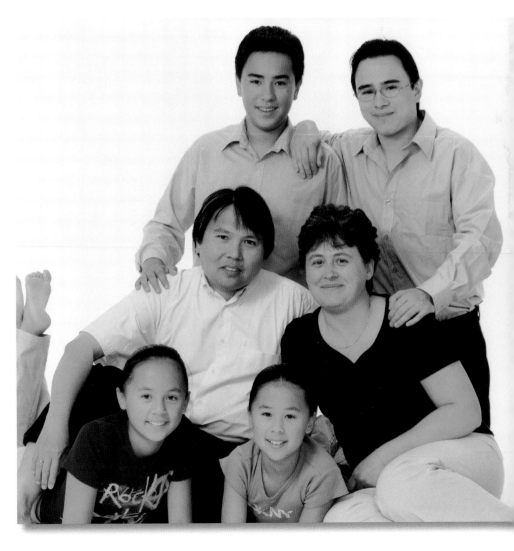

Materials

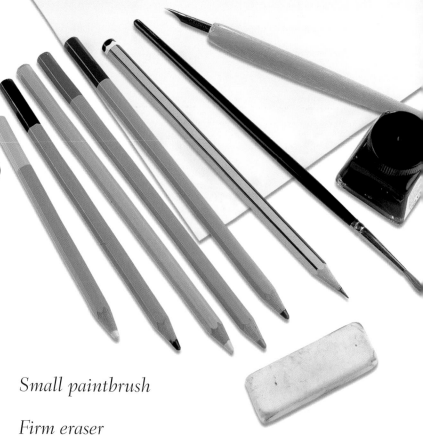

Sheet of 300 gsm NOT paper
420 x 297 mm (16¹/₂ x 11³/₄ in)

2B pencil

Dip pen with fine
steel nib

Black Indian ink

Water-soluble coloured pencils
in golden brown, light flesh,
warm grey, dark grey, burnt
umber and black

Small paintbrush

Firm eraser

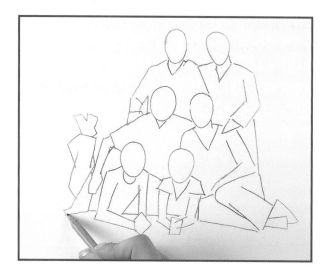

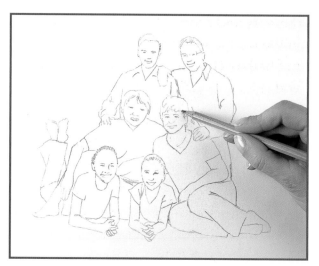

1 Sketch out the overall composition with the 2B pencil, paying attention to angles and proportions and comparing them with others in the picture as you work. By now, you will be able to recognize and identify meaningful shapes in the entire image – that is, viewing the negative shapes (background and surrounding area) as well as the positive ones (the figures themselves).

2 While maintaining your focus on the empty negative shapes, you will be determining proportion, placement, size and shape. Once you have the basic shapes down, begin to work on the details of the figures using light pencil pressure and fluid strokes. Mark on the whereabouts of the facial features and the sleeves and necklines, plus a hint of the hair shapes.

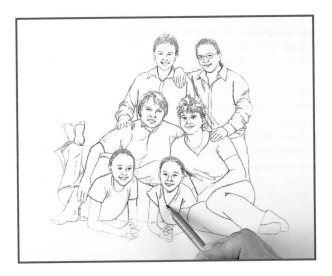

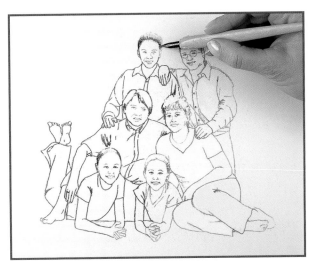

3 Build up the details of the clothing, hair and facial features using lines only and no shading. Look at things like the angles of the shirt button lines, the angles of the shirt sleeves and the shapes and proportions of the eyes and noses. Note that the girl's feet in the front appear slightly smaller than you might expect because they are in perspective and recede towards the back.

4 Once you are satisfied with the drawing, using the dip pen and ink, begin by drawing the figures lightly and with broken, fluid lines. Keep lifting your pen off the paper to ensure that no line becomes too heavy or too laboured – or worse – blots! Work across your drawing, only indicating the texture of folds and creases. You will not be adding tones with the pen and ink as you will use the coloured pencils for that.

5 Draw across the paper in the same way, using broken, light lines, indicating folds and creases with light scribbles or dashes. Pay attention as you work to the way that each person 'links' with another in the family through the direction that they are leaning or their hand resting on another family member. Make sure that you draw away from your drawing hand, so that you avoid smudging the fresh lines with your working hand.

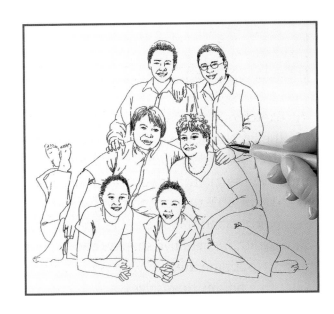

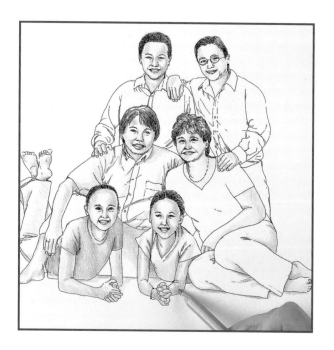

6 Once the drawing is completed, build up some hair, drawing in small dashed lines in the direction of growth. Use tiny dashes to build up eyebrows and little marks to indicate toes, fingers and facial features. Take the water-soluble coloured pencils in golden brown, light flesh, warm grey and burnt umber and lightly shade the areas as you see here, being careful not to colour in the flesh-tones in whole blocks of colour. Instead leave untouched areas of paper to show highlight on the skin. Use the dark grey in areas of shadow under the front figures and on their shoulders where the light casts the shadow of their heads.

7 Continue colouring in gently, allowing the white paper to show through in places. Use grey for the black clothes, then add some black in the darkest areas. You do not want a blanket of black with no indication of shape as this will flatten any impression of three dimensions. Using the blue pencil, shade only where the shirts and girl's jeans are darkest. Add touches of burnt umber layered with light flesh on the lips, mainly at the outer edges. Finally, using a clean brush, add a little water to spread and blend the colours carefully, ending your brushstrokes where you want the darkest tones.

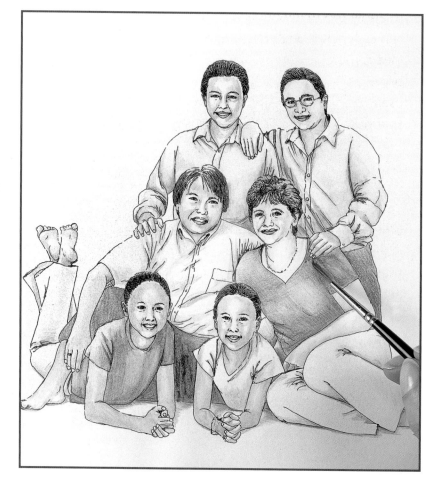

TRY A DIFFERENT ...

... MEDIUM

The same image is drawn here with coloured pencils on buff-coloured paper. Colours were applied in layers to build up the various skin, hair and clothing colours and tones. Areas of paper have been left to describe the lighter mid-tones and white coloured pencil indicates the brightest highlights. As with the main drawing, half close your eyes to focus on the darkest tones and brightest highlights and don't try to apply too many details as this can distort the picture. A general idea is more important to create the light, relaxed mood of the pose. Dark and light brown, dark and light blue, warm grey, white and flesh or peach were the main colours used. Black has also been used for the man's trousers and the woman's top, but use black sparingly in drawings as it can 'deaden' the drawing.

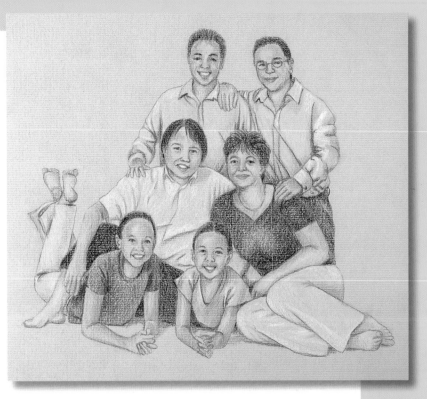

... POSE

Try drawing the same family in a slightly different pose. This picture is in portrait format, and the resulting composition is almost an inverted triangle. When drawing this picture, note the echoing shoulder shapes and angles, the slight tilts of each head, and the 'pattern' the negative shapes make (for instance, the triangles between the man's arm and leg, and hand and two legs). Never try to draw every tooth in a smile, every hair or every detail of each finger. Just a hint at these details is sufficient to keep the whole image lively and fresh.

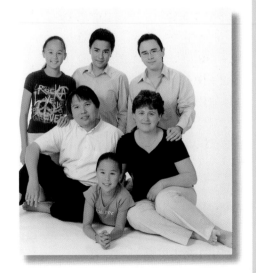

Suppliers

UK

The Arthouse
59 Broadway West
Leigh-on-Sea
Essex
SS9 2BX
Tel: (01702) 071 2788
Wide range of art supplies

Cass Arts
13 Charing Cross Road
London WC2H 0EP
Tel: (020) 7930 9940
&
220 Kensington High Street
London W8 7RG
Tel: (020) 7937 6506
Website: www.cass-arts.co.uk
Art supplies and materials

L Cornelissen & Son Ltd
105 Great Russell Street
London WC1B 3RY
Tel: (020) 7636 1045
&
1a Hercules Street
London N7 6AT
Tel: (020) 7281 8870
General art supplies

Cowling and Wilcox Ltd
26-28 Broadwick Street
London W1V 1FG
Tel: (020) 7734 9556
Website: www.cowlingandwilcox.com
General art supplies

Daler-Rowney Art Store
12 Percy Street
Tottenham Court Road
London W1T 1DN
Tel: (020) 7636 8241
Painting and drawing materials

Daler-Rowney Ltd
PO Box 10
Southern Industrial Estate
Bracknell
Berkshire RG12 8ST
Tel: (01344) 424621
Website: www.daler-rowney.com
Painting and drawing materials
Phone for nearest retailer

T N Lawrence & Son Ltd
208 Portland Road
Hove BN3 5QT
Shop tel: (01273) 260280
Order line: (01273) 260260
Website: www.lawrence.co.uk
Wide range of art materials
Mail order brochure available

John Mathieson & Co
48 Frederick Street
Edinburgh EH2 1HG
Tel: (0131) 225 6798
General art supplies and gallery

Russell & Chapple Ltd
68 Drury Lane
London WC2B 5SP
Tel: (020) 7836 7521
Art supplies

The Two Rivers Paper Company
Pitt Mill
Roadwater
Watchet
Somerset TA23 0QS
Tel: (01984) 641028
Hand-crafted papers and board

Winsor & Newton Ltd
Whitefriars Avenue
Wealdstone
Harrow
Middlesex HA3 5RH
Tel: (020) 8424 3200
Website: www.winsornewton.com
Painting and drawing materials
Phone for nearest retailer

SOUTH AFRICA

CAPE TOWN
Artes
3 Aylesbury Street
Bellville 7530
Tel: (021) 957 4525
Fax: (021) 957 4507

GEORGE
Art, Crafts and Hobbies
72 Hibernia Street
George 6529
Tel/fax: (044) 874 1337

PORT ELIZABETH
Bowker Arts and Crafts
52 4th Avenue
Newton Park
Port Elizabeth 6001
Tel: (041) 365 2487
Fax: (041) 365 5306

JOHANNESBURG
Art Shop
140ª Victoria Avenue
Benoni West 1503
Tel/fax: (011) 421 1030

East Rand Mall Stationery and Art
Shop 140
East Rand Mall 1459
Tel: (011) 823 1688
Fax: (011) 823 3283

PIETERMARITZBURG
Art, Stock and Barrel
Shop 44, Parklane Centre
12 Commercial Road
Pietermaritzburg 3201
Tel: (033) 342 1026
Fax: (033) 342 1025

DURBAN
Pen and Art
Shop 148, The Pavillion
Westville 3630
Tel: (031) 265 0250
Fax: (031) 265 0251

BLOEMFONTEIN
L&P Stationery and Art
141 Zastron Street
Westdene
Bloemfontein 9301
Tel: (051) 430 1085
Fax: (051) 430 4102

PRETORIA
Centurion Kuns
Shop 45, Eldoraigne Shopping Mall
Saxby Road
Eldoraigne 0157
Tel/fax: (012) 654 0449